GUY BRETT

THROUGH OUR OWN EYES

POPULAR ART
AND
MODERN HISTORY

new society publishers

World copyright © 1986 Guy Brett
U.S. copyright © 1987 Guy Brett

This edition is published in parallel:
– in the UK as a Heretic book by GMP Publishers Ltd, P O Box 247,
London N15 6RW
– in the USA by New Society Publishers, 4722 Baltimore Avenue,
Philadelphia, PA 19143

British Library Cataloguing in Publication Data

Brett, Guy
 Through our own eyes: popular art and modern history
 1. Popular culture 2. Arts and society
 I. Title
 306'.47 HM101

ISBN 0-946097-20-8 (UK paperback)
ISBN 0-86571-093-7 (US paperback)
ISBN 0-86571-092-9 (US hardback)

Cover: 'Lumumba', by Ndaie, a Zairean popular painter. Patrice Lumumba, nationalist leader and first Prime Minister of independent Zaire, is brought bound to Lububashi airport shortly before his murder in January 1961 by Western backed secessionists.

Photosetting by Artworkers (Typesetters) Ltd, London N16
Printed and bound by South Sea International Press Ltd, Hong Kong

THROUGH OUR OWN EYES

POPULAR ART
AND
MODERN HISTORY

And I always thought: the very simplest words
Must be enough. When I say what things are like
Everyone's heart must be torn to shreds.
That you'll go down if you don't stand up for yourself
Surely you see that.

Bertolt Brecht, 1956[1]

CONTENTS

Acknowledgements

This book is called *Through Our Own Eyes* – as if those who painted the pictures, embroidered the patchworks and so on, were also its authors. But I have been constantly aware that it is *my own* eye which has made the choice of reproductions. In every case, a very small selection has been made from hundreds of images, which themselves may have been sifted from thousands more by other intermediaries. In most, though not quite all cases the artists remained unknown to me personally. While I wanted to efface myself, and simply point to the existence of an extraordinary popular vitality, I also knew I was constructing an argument, according to ideas which have been strongly influenced by the work of contemporary 'professional' artists and writers. But just as a number of these artists have shown in their work, in diverse ways, that 'where one speaks, several speak,' I also wanted to try to avoid a single vantage-point. My position is between, and I wanted to take as a theme the relationship between people, moments of historical crisis, and the visual means of expression.

I would like to thank the many people who have given their interest and help in the completion of this book, especially Herbert Cole, Gabriela Gelber, Mona Hatoum, Susan Hiller, Malcolm Imrie, Kazuhiro Ishizu, André Jacques, Moriaki Kawamura, Beeban Kidron, Chantal Lombard, Deborah Lowensburg, Roberto Matta, Laura Mulvey, Ben Oelmann, Rozsika Parker, Jean-Louis Paudrat, Carmen Waugh, Yang Chih-hsien.

Chapter 3 makes clear my great debt to the study of Ilona Szombati-Fabian and Johannes Fabian on Shaba painting which I warmly acknowledge here again. I would also like to thank Etienne Bol, and his father Victor Bol, for their help and for letting me reproduce Shaba paintings from their collections. Acknowledgement is made to the following for permission to reproduce pictures in their collections: Gunther Peus, Hamburg ('Not for Friend II' by Y.K. Special, p.101); University of Bayreuth ('Family', p.101 and 'African Barber', by Willy Arts, p.107); Saatchi Collection, London ('Atomic Bomb' by Andy Warhol, p.115).

Finally, I would like to thank Alejandra Altamirano for her encouragement and support at every stage of the project.

INTRODUCTION

POPULAR ART, MODERN HISTORY

In periods of overwhelming historical change, groups of 'ordinary' people have sometimes reached for art as a means to express the experiences they are going through. Without artistic training, and using whatever materials are to hand, they have nevertheless produced intensely moving images. This book is an attempt to study these productions as an artistic and social phenomenon of great significance, which can often give a deeper insight into the contemporary world than the major established forms of art, or of the mass media.

This may seem to some an elevated claim for a form of expression which appears crude and elementary and for which there is anyway in the lexicon of Western taste a special category, a special sub-section of the art market: naive art. To bring this material together in a book is to claim links between expressions which originate in very different circumstances; not only at different periods, in different countries, under different social and political conditions, but also dealing with kinds of experience as utterly opposed, for example, as the building of socialist communes in China and the nightmare suffering of the nuclear attack on Hiroshima. Making a book of the material also gives the look of established permanence to forms of expression which came into existence precariously: out of poverty, in the face of the hostility or indifference of the authorities, without cultural precedent, often traceable to the 'crazy' initiative of one individual or a small group of people.

But it is just those factors making these expressions look crude, fragmentary and insignificant vis-à-vis the established forms of art and communication which are a key to their importance. For they cross the usual barriers defining and controlling our knowledge of the historical events of our own time as they affect the mass of people. For those *outside* such events they give the inside view, they give insight into the events and into the feelings and desires of those involved which are available in no other way. And for those *inside* the events they are the means of articulation and self-definition, of becoming conscious of their history and the meaning of the things which are happening to them. The Brazilian

7

educationalist Paulo Freire invented the term 'the culture of silence' to describe the condition in which the impoverished majority of the world's people are living – powerless, and with little access to the means of communication, from literacy on up to the mass media. The culture he describes of course is not one-sided: there is also the silence and ignorance in which the affluent minority of the world is kept by the media and the powers which stand behind them. These popular expressions cross over between both silences.

Paradoxically, the more intensely these images express a local reality and a local experience, the more global they seem to become. This is not only because the matters they deal with are internationally relevant, and they themselves may be disseminated and understood anywhere in the world, but also I believe because of a changed relationship today between the local and the global. One cannot be seen without the other. At a time when the means of destruction, of vaporization, of our neighbourhood are already targeted on us from thousands of miles away, when a decision taken in Aylesbury can throw someone out of work in Korea, when misery and suffering are so precisely localized (and seen as such on TV), while their perpetrators escape into the intangible global systems of capitalism and imperialism: in this reality the old norms of geography and nationality are broken through. Even though the world may be more unjustly divided than ever, these paintings challenge the notion that any part of it can be treated as peripheral or marginal to any other.

Paradoxically also, the more one itemizes the different circumstances out of which these images have appeared, the more striking become certain common features in the pictures themselves. One of these is the emphasis given to the group, to the individual as a social being. Another is the attention given to material detail of every kind. Individuals rarely appear except in significant relationships to one another, to nature/ landscape and to the objects they use or that affect them. Material details of suffering and hardship, as well as details of everything which may improve life, rather than rhetoric, are the means of expression. Whether for good or ill, they emphasize everything which is new and changing. Whatever their stylistic limitations, they express collective pain, or collective energy and élan, in a way which seems beyond the individual professional artist. The effect of all this is again to clear away sentimentalities and stereotypes imposed from outside and create a new 'image of the people', a democratic self-image, in the conditions of today.

●

Production of vernacular art of this kind seems to be widespread. But how widespread, and exactly where its limits and edges are, is tied up with the problem of defining it as a distinct phenomenon. I have concentrated on five 'movements', in five different places, times, and five very different circumstances, partly because I had more information about them and partly because they answered, or suggested, the criteria for recognizing this new cultural upsurge: self-taught or untaught artists expressing and forming the experience of whole groups of people (in the African case, including children as well as adults) in the midst of profound historical changes. In each case my first reaction was to be drawn, to be fascinated, by the images themselves, and then to find out more about them. (For example, I first saw the Hiroshima paintings in a TV documentary about the Bomb. Surrounded by old film clips, photos, diagrams and so on, they became immensely powerful and seemed to express the inner and outer reality of the event, the personal and public, in a way beyond the other media.)

There is certainly a danger in making links between pictures which come from very different realities. What is powerful and significant in each case can become diluted. And the differences are many. There are not only the obvious ones of the kinds of experience the pictures depict. There are also differences of intention behind the images, and in the scope of this study. Chapter 3, for example, describes some new and vigorous forms of urban popular art in Africa which have no precedent either in traditional African art or in the various forms of ethnic and tourist art for Westerners. Here the scope is very wide, alluding to practically the whole continent, and to images as varied as bar paintings, shop signs, religious statuary, historical and mythological paintings for people's houses, and even children's toys. Yet whether produced by self-taught urban popular painters, by villagers selected to construct a local shrine, or by children, all reflect Africa's encounter with modernity.

The Chinese amateur peasant painters (*Chapter 2*) are people of all ages who paint in their spare time from farming work. In one county – Huxian near Xian in central China – a movement of painting grew from a grassroots initiative to accompany and portray the revolutionary transformation of the countryside from feudal serfdom to socialist commune during the years 1949 to 1976. Here the question of popular viewpoint and creativity is tied up in revealing and complex ways with an epic programme of 'building socialism', an undertaking which is both practical and philosophical, and generally views art as a mobilizing force.

Where the Chinese paintings can be public and celebratory, the Chilean patchwork pictures (*Chapter 1*) have been produced in conditions of great insecurity. They again appeared without precedent, after the brutal military coup of 1973, among relatives of the political prisoners and among

9

groups of women in the poorest sectors of the capital, Santiago. Often in coded form to avoid censorship, they have given a detailed, almost month by month chronicle of what it means to live at the bottom of the social pyramid, under a repressive regime, in the conditions of 'underdevelopment'. Nevertheless, each harsh image is turned into a sign of hope by the wit and richness of its embroidery.

The eye-witness paintings by survivors of the atomic bombing of Hiroshima and Nagasaki (*Chapter 4*), and the forms of expression which emerged during the women's peace demonstrations at Greenham Common air base in southern England (*Chapter 5*), have the same general intention: to rid the world of nuclear weapons. But there is clearly a vast difference between the experience of a real war, and the fear of the possibility of war. The depth of the shock of Hiroshima is made clear by the fact that these drawings and paintings were produced from memory nearly *thirty years* after the event. In the immediate aftermath many had sworn they would never discuss or mention their experiences to others. Though the occasion for Greenham Common was a protest against the installation of American cruise missiles in Britain, it came to express a much more generalized revulsion against the society of 'profit, gain, aggression and domination'.

Other levels of difference also cut across the grouping of these images. The social and economic conditions of African workers, or Chilean shanty-town dwellers, who remain among the 'impoverished majority' of the world, or Chinese peasants just emerging from these conditions, are distinct from the inhabitants of wartime Hiroshima, as a cross-section of urban citizenry, or again from women at Greenham who are relatively speaking among the privileged of the world. Terms like 'the people' or 'popular art' applied equally to all these groups can become glib and apolitical. Any discussion of art which made nothing of these differences would be merely formalistic.

10

And yet, as hinted before, the itemization of differences can make all the more striking certain common characteristics. In each different context these forms emerged as an autonomous response to the experience of oppression. They emerged as part of the act of standing up for oneself against domination; and either explicitly or implicitly asserting a world of different, human values. They change our preception not only of reality, but also of art – of what it is and what its potential role could be.

●

One aim of this book therefore is to avoid the usual kind of art discussion which is either preoccupied with authorship, the experience and style of

one unique individual, or with the great traditions of classic and popular art. Authenticity in art is usually identified closely with these two categories, a notion supported by the logic of the art market. Each of the manifestations of vernacular art described here is a beginning, not a refinement or development of a tradition. A seed, a new direction. This book is more about the artistic impulse, the creative, communicative impulse face to face with the great upheavals of our time, understanding that those upheavals could be sudden and cataclysmic like the bombing of Hiroshima, or drawn-out like the industrialization and change from colonial to postcolonial society in Africa. They could also make visible aspects of the world previously hidden by the barriers of class, such as the details of agricultural work shown with such inner knowledge and panache by the peasant painters of China.

The emphasis should fall equally on the people, the event, and the means of expression.

There are in fact many ways in which all three realities are tied together, in a process. The events are closely tied, not only with the specific art works produced in each case, but with the general nature of art as well. On one level art here becomes a means of communication in which *facts* are not separated from *feelings*, in which human beings present themselves clearly as both observers of, and participants in, events. On another level art becomes a means of therapy in order to survive the trauma of events, or, in a kind of updating of what was once considered the function of shamanism in tribal societies, to 'give structure and coherence to the unfathomable and intangible.'[2] Art also become the means to retain one's humanity when that humanity is threatened. Wit and pleasure in representing become the guarantee of humanity. The artists' discovery of, or relation to, their audience is also inseparable from specific historical conditions. In the case of the paintings produced in the mining settlements of Shaba province, Zaire – African paintings for an African public – the appearance of both coincided with Zaire's accession to independence and was indicative of the masses' resilience and sense of identity through the years of colonialism. In Chile, during the 'cultural blackout' imposed by the military, the patchwork makers realized they had an audience and a market outside the country (which they need for survival, as much as the Zaire painters do their local market) among millions of people who have watched Chilean developments closely as a lesson for their own. Chinese peasant painting evolved in a kind of spiral development in which an individual painter took his/her picture for suggestions and criticism back to other commune members and enriched it as an inspirational icon in an epic agricultural programme. In Japan, the flood of suppressed memories released so long after the bombing, and almost by chance, was expressive of the indifference of the authorities both in Japan and abroad to the

11

'inside view' of this overwhelming event, and of the survivors' latent need for an audience.

It is a feature of popular and vernacular art to use materials near to hand, out of urgency or necessity. But in these cases they too become closely identified with specific events, specific messages: the waste scraps of mass-produced cloth used by the Chilean women, the ex-American flour sacks used as supports by both the patchwork makers and the Zaire painters; paints originally made with earth and soot by the Chinese painters; the backs of envelopes and bills, felt-tipped pens, by the inhabitants of modern Hiroshima; wool, clothes, toys, cards, things from bags and pockets by the women peace demonstrators of Greenham Common, and so on.

The process which makes the event and the artistic expression so connected in the eyes of outsiders, must appear inadequate and fragmentary to the individuals involved. Demands of the situation direct creativity into channels by necessity; this is not *everything* of the artists, their full individuality. The means of expression are provisional, they do not represent what people really want. Nevertheless, it is probably true that these extreme situations are inescapably connected with the springs of poetry and art. People are turned into artists by the pressure of events (the fact that they have no training does not hold them back), pressures which heighten a need for art in its multiple role of therapy, desire, communication, memory and love of beauty, which is present in everybody but which is stifled in modern normality.

The most obvious thing that the images in this book have in common is their rudimentary, untrained methods of representation. These may strike a spectator as pathetically crude in relation to the artistic traditions of the people to whom the artists belong, or as naively charming. Both responses seem to me a good starting point for insight into this artistic phenomenon of the modern world. It is true that the Huxian paintings have a hybrid awkwardness compared to the sophistications of classical Chinese landscape painting or refined forms of popular art like papercuts and woodcuts; the African paintings seem to have substituted a simplistic Western realism for the metaphorical and formal power of traditional African art, and so on. But part of the historical experience which the African, Chinese and Chilean people picture in their work is the displacement from a traditional cultural context. In China, for example, culture was divided along class lines (classical landscape painting was 'scholar' painting). Many popular arts and crafts were closely derived from upper-class models, and even these by the early 20th century were in decay because of the flooding of the countryside with cheap Western goods. In Africa, as in all Third World countries, vast numbers of people migrated from their villages to the new cities in search of work. All this is well

known. The process of capitalism and industrialism broke up the old cultural collectivities where everyone is both spectator and performer, where 'everyone is a poet', as George Thomson could still find in the Irish peasant villages of the 1930s:

> For them poetry has nothing to do with books at all. Most of them are illiterate. It lives on their lips. It is common property. Everybody knows it. Everybody loves it. It is constantly bubbling up in everyday conversation ... In many Irish villages there was till recently a trained traditional poet, who had the gift of producing poems, often in elaborate verse forms – far more elaborate than ours in modern English – on the inspiration of the moment ... But I soon found that no sharp line could be drawn between the professional poet and the rest of the community. It was only a matter of degree.[3]

Writing of Italy as recently as 1975, Pier Paolo Pasolini felt that the consumerist revolution, as directed by the Italian ruling class, had brought about 'the most complete and total genocide of restricted (popular) cultures that Italian history records':

> The sub-proletarian youth of Rome ... have lost their 'culture', that is, their way of life, of behaving, of speaking, of judging reality; they have been provided with a model of middle-class (consumerist) life ... the atrocious unhappiness or criminal aggressiveness of the proletarian and sub-proletarian youth derives precisely from the mismatch between culture and economic conditions – from the impossibility of attaining (except by imitation) middle-class cultural models because of the persistent poverty which is masked by an illusory improvement in the standard of living.[4]

13

Nevertheless, taking the world as a whole, the fate of traditional popular cultures in the 20th century has not been a straightforward one of destruction or obliteration. They have sometimes been destroyed, at other times appropriated or modified as they have become entwined with ideological struggles. One could point to several different strands in this complex process. In the wake of the steamrolling imperialist and capitalist machine there were always a few individuals who studied, loved and tried to preserve the indigenous cultures. To them is owed valuable knowledge that might otherwise have been lost. But as the colonial system changed to the neocolonial, their efforts were overtaken by the vulgarization and commercial exploitation of indigenous arts as tourist attractions. At the same time, as the other side of the coin, the rediscovery and reappraisal of their own culture has been a vital part of all popular liberation movements

in the 20th century, from the Soviet Union and China to El Salvador and the Native Americans. They have made their traditional culture part of their ongoing struggles, by seeking its 'democratic essence', those aspects which can contribute to unity, equality, to the solution of problems, the sense of well-being, and so on. Only when liberation movements have later petrified into traditional power patterns, as today in the Soviet Union, have these forms been reduced to static and sentimental emblems of a supposed popular credibility.

Another strand in this web is the huge part played by popular and precapitalist art forms in the formation of modern art. Seeing these forms as a source of vitality and radical ideas was closely connected with criticizing a decaying bourgeois culture – this was George Thomson's motivation, for example. The process continues up to today with movements like 'participation' and 'performance' art, whose influence could be felt at Greenham Common (p128).In other words, this problem can never be seen in purist terms. Images like those in this book come into existence between the break-up of old and the emergence of new collectivities.

●

As they appear in the metropolitan art world, however, these images would be put, by almost conditioned reflex, in the category of naive art. The development of modernism has made people receptive to the appeal of 'naivety' in art. Painters like Paul Klee, Picasso and others developed a kind of complex of formal devices in which the art of children, untrained people, erroneously labelled 'primitive art', psychotic art, spontaneous grafitti and so on came to be identified as belonging to a single broad genre. Part of the formation of modernism was the promotion of naive artists like Rousseau by Picasso and others or Cheval by the Surrealists. This was undoubtedly first felt as a liberation. I believe that historically the validation of children's art, for example, the child's perception – of childhood as such – was connected not just with the challenge to the art academies but to traditional authority as a whole. This is the sense of Picasso's provocative remark: 'For me to draw like Raphael was easy, but I had to learn to draw like a child.' Or the way in which an early 20th-century writer like Lu Xun in China set childhood as a model of progressiveness and modernity against the rigidities of the ancestral Confucian social system. But gradually, as the logic of the art market attempts to coopt all progressive insights and taste degenerates, 'naivety' becomes a fixed category of commodity which cannot be allowed to change. Today, there are many degrees and nuances of play on the 'look' of

14

primitivism in art. Even 'bad art' in the sense of deliberately summary, slapdash execution and crude figuration has become a new and lucrative category of sophisticated taste in the West.

These vernacular expressions are a fundamentally different phenomenon because their 'naivety' comes from necessity and not from choice. It is not a style adopted knowingly in relation to other styles, but an expression of the urgency to communicate conditioned by existing material realities (meaning both art materials and the artist's access to technique). For the artists it is always inadequate: 'These pictures are poor in quality if you judge them for artistic quality and technique. We want to tell you that these things actually happened ...'[5] Even so, such inadequacies are a double phenomenon. From the audience's point of view this naivety is also the bearer of a precious, fresh perception. The rawness of the art is somehow tied up with the newness of the experience – and with the act of standing up for oneself, even though powerless. Minimal expressive resources are combined with having something overwhelming to communicate. Everyone today feels this paradox strongly since the world of professional art, graphics and advertizing gives so many examples of highly sophisticated techniques signifying ... nothing.

This is not to say that such naivety will be read in the same way by everybody. The Chilean patchworks have provoked two reactions abroad. Most people see them as a moving testimony, and the wit of their embroidery as an assertion of popular resistance. But for others, the visual combination of an innocent, childlike style and horrific events is just not right, not appropriate. Inside the country, their naivety has had the advantage of disguising a defiant protest in the appearance of a harmless handicraft. And the military authorities in Chile have never known quite how to react to the *arpilleras*. Are they a threat or not? The women of the shanty-towns do not measure up to their idea of artists, nor do the little 'landscapes', 'street scenes' and 'interiors' excite their Pavlovian response to the clichés of left agitation.

The two aspects of the rudimentary nature of vernacular art – its detachment from the idiosyncracies of the cultural traditions of a particular people and its lack of learned visual codes (which even advertizing today depends on) – are two of the reasons it can speak so directly to people all over the world, from children to old people. Of course both these 'lacks' are only relative. There is no dogmatic principle involved. The Chinese peasant paintings do draw on traditional Chinese 'vertical' composition as well as local folk art. The African paintings have a strong story-telling element, suggesting an oral culture. The Chilean patchworks modify a decorative technique used locally. The forms of expression at Greenham Common are linked, even if unselfconsciously, with the inventions of the avant-garde, such as collage and performance

art. Even the Hiroshima paintings echo some traditional Japanese methods of rendering the human figure in line. All these are cultural particularities. But the general 'feel' of these forms of art is to bypass national and ethnic stereotypes and communicate directly about matters of concern to us all. In this respect they may point a way towards a future art.

Perhaps the outstanding way they differ from the models of 'naive art' which have become best known, is the emphasis they place on the social and historical. They show individuals as social beings and reality as changing. The best-known models of naive art (the Douanier Rousseau – Facteur Cheval tradition) are mainly concerned with individual private fantasy, or with an image of popular, communal life which is idealized and static. Cheval's world was a world of mythological fragments filtered down since the days of antiquity into the private head of the 20th-century 'little man'. Curiously enough Cheval was a postman, a go-between in a network of private communications which were not revealed to him. Rousseau was a customs official, an individual interceding in the movement of people and goods in the abstract name of the state ...

These models formed the basis for the quality of naive 'charm' around which the market for this kind of art developed. It has become the positive quality projected onto all superficially similar artefacts whatever the real meaning. The anthropologists Johannes Fabian and Ilona Szombati-Fabian have shown the absurdity of this in relation to one of the categories of Shaba popular art: animal paintings. Adjectives that we might use about such pictures, such as 'charming' or 'quaint', are totally absent from the critical language used by the producers and consumers of this art. These are 'powerful animals'. 'For the African beholder they are images of power and danger; they inspire awe. They recall a village past (where they were, above all, symbols for political and magical authority) and thus have a definable position in history'.[6]

The market is certainly interested in coopting these vernacular expressions, but has met with differing degrees of success because of the different conditions affecting each body of work. China has no commercial art market in the Western sense. The peasant paintings were not for sale. The conditions of their production, exhibition, reproduction and so on were controlled as an internal matter by the Chinese cultural authorities. No foreign entrepreneur could commission a Huxian painter to produce more or different pictures. In the case of the Chilean patchworks the intermediary in their production has always been the Roman Catholic church in Chile which collects, distributes and markets the pictures abroad at a fixed price, returning fixed payments, admittedly very small, to the producers. They have usually been exhibited abroad in the context of solidarity meetings and Third World events, where their meanings could be explained. The situation of the Shaba paintings has

been much more open. Since I. Szombati-Fabian and J. Fabian's pioneering study (see pp 84-95), dealers, collectors and commentators have descended, making various offers. As a result there have been quite a number of Shaba paintings circulating without any information about their origins or meaning in their own cultural environment. This reveals all the more clearly that the art market is indifferent to the social place and effectiveness of works of art.

The Hiroshima paintings are a completely different case. And this is not only because there is no way they can be consumed at the level of naive charm. They could also, for example, be put in the category of atrocity pictures, which lose their effect by mindless repetition. There is always the incipient danger of this happening. But the survivors' paintings have been surrounded by the Japanese with an aura of respect, which begins at the level of respect for the individuals, many still living, who produced them, and who themselves often dedicated them with a memorial epithet to those who died. When I wrote for permission to reproduce some of the paintings, Mr Moriaki Kawamura, chairperson of the Hiroshima Peace Culture Foundation, replied in his letter:

> ... their ultimate feeling that nuclear weapons should never be used in war made the survivors draw such impressive pictures. They did it overcoming their deep sorrows and hatreds. Therefore, you have to use these pictures with the utmost care so as not to wound their susceptibilities.

And he asked:

> What is your purpose in publishing this book?

●

The efforts of the Hiroshima survivors and their supporters to circulate their images as widely as possible, and at the same time to control the spirit in which people approach them, raises a perplexing issue of contemporary culture. What is the relationship between the mass reproduction of imagery and its spiritual effect? In his often and deservedly quoted essay 'The Work of Art in the Age of Mechanical Reproduction', which was written in 1936, Walter Benjamin first drew attention to the tremendous changes made to our perceptions by the new technology of mass visual reproduction, and he welcomed it as a progressive trend. He saw it as linked with revolutionary political and social movements, an expression of the desire of the masses and a 'tremendous shattering of tradition'. Its most

radical result was to destroy the 'aura' traditionally surrounding works of art:

> To pry an object from its shell, to destroy its aura, is the mark of a perception whose 'sense of the universal equality of things' has increased to such a degree that it extracts it even from a unique object by means of reproduction.[7]

The aura of the work of art derived from its uniqueness, and from the close association historically between art and ritual.

Today, few would deny the revolutionary implications Walter Benjamin discerned, or dispute his identification of an uncontrolled use of traditional aesthetic concepts – 'creativity and genius, eternal value and mystery' – with the purposes of fascism. But time has considerably complicated the clear opposition he drew between the new and the old. For one thing, the new technical developments did not so much overturn as extend and strengthen established patterns of power. Mechanical reproduction has not in practice served to articulate the desires of the masses. The 'sense of the universal equality of things' has become the neutralization of the differences between things in the spectacle of the mass media. Instead of a democratic interchange of people's experience and culture, the images issue from the centres of power as models of conformism, hollow flickering chimeras of consumerism or 'socialist' community.

On the other side, the notion of the 'aura' need not be identified only with perceptions which seem archaic and obsolete, such as the uniqueness of the work of art and its association with the hierarchies and rituals of fossilized world views. For the 'aura' is also tied up with the ongoing tradition of art as communication, with the idea that cultural artefacts are potent and efficacious – 'things that work' – in the personal and social lives of human beings. Such ideas derive from art's original association with magic, or in other words, with the traditional existence of a unified aesthetic-scientific practice. 'The followers of Orpheus and Pythagoras,' according to Alfred Einstein, 'still saw in music a magical means of purification and healing.'[8] Sounds, and images, had to be handled with the utmost care if they were to work, if they were to keep their psychic charge.

The American artist and anthropologist Susan Hiller – who herself has used vernacular and traditional cultural artefacts as the basis for moving and perceptive contemporary art works – has pointed to the example of the shields of the North American Plains Indians. Each shield was painted with a cryptic design representing the personal dream or vision of its owner. These designs were never uncovered except just before battle when the owner would pull aside the painted covering and contemplate his

18

shield. Recapturing a sense of himself as a spiritual – and therefore invulnerable – being, he would overcome his fear.

Susan Hiller referred to the shields in a review she wrote of the 1978 exhibition *Sacred Circles*,[9] a jamboree of the collectors and dealers of Native American art, the museum and political establishments, intended, with bitter irony, to celebrate 200 years of American independence. Susan Hiller severely criticized the organizers for displaying the Plains shields nakedly, without their painted covers. This small detail revealed more than just a Western museum's insensitivity to the North American Indian mode of display. It showed that the organizers did not believe in cultural artefacts as efficacious within a people's spiritual and practical life and within their history. The same attitudes involved in acquiring, stripping, exhibiting (and by implication also, mass-reproducing) the shields as objects of 'world art', are implicated in the annihilation of the people who made them. In this destruction of the aura, this prizing of the object from its shell, could be read not so much a mass accessibility to culture, as the capitalist commodification of aesthetic feeling and the imperialist assumption that the whole world is available.

If the notion of an aura *can* be applied to these vernacular expressions, it has nothing to do with the uniqueness of the object or the reputation of its author, or any ritual function. It derives from their inseparable connection with historical events which everybody considers to be important. Their psychic charge has to do with their revelation of the significance of these events in human terms, and it is this, by careful presentation and contextualization, that has to be prevented from withering away in the mass reproduction and consumption of imagery.

●

For Walter Benjamin, the characteristic art forms of the age of mechanical reproduction were photography and film. They were the products of the same processes and changes of perception:

> The painter maintains in his work a natural distance from reality, the cameraman penetrates deeply into its web ...[10]

It is easy to see the sense in which this is true. But again, if you look more closely it is not so simple and the distinction between the new and the old is not so clear-cut. In the event, and in the reality of a world divided between a small elite and a mass of people without wealth or power, there is a sense in which photography, film, TV and all the mass visual media remain at a distance from reality, and in which 'primitive', rudimentary, 'poor', marginal forms can penetrate it more deeply.

19

From the new transmitters came the old stupidities
Wisdom was passed on from mouth to mouth.

Bertolt Brecht[11]

One of the most striking facts about the mass visual media, which have achieved such a charismatic presence in everyday life, is that they themselves are an odd combination of the new and the old. Advanced technical innovations go together with 'systems of representation' as old as the Renaissance. Photography, film and TV, whatever the technical complexity of their production and transmission, are all based on the Renaissance invention of perspective, the optical projection of the world on a flat screen. Their images, as critics have increasingly pointed out, are not simply 'reflections of reality' but constructs arising from a definite philosophy and world view. Perspective was an expression of a particular notion of the human individual in its relation to society:

> The image that a photograph gives you, the image that a Renaissance painting gives you, the image that a perspectival system of representation in general gives you, is the image of this individual (ie. *the omniscient overview of society*): the world in the image *radiates* from that individual and returns *to* that individual along the lines of geometric projection.[12]

Perspective and Renaissance painting itself had been the product of the convergence of aesthetic sensibility, scientific and philosophical thought, and practical experiment. But the mass visual media have been chiefly the product of practical experiment and entrepreneurship. The origins of the cinema lay in the sideshows of amusement arcades. The technical drive of the inventors of photography and later of people like Baird went together with an unquestioned, common-sense view of the nature of the image. Experiment in the 'systems of representation' has been the specialization of avant-garde artists, whose intellectual methods and discoveries, within the terms of their particular field, were somewhat parallel to those of scientists. In fact technical and artistic experimentation in the modern period have tended to be antagonistic to each other, since the great capital investment in technical ideas – radio, films, TV, video, etc. – has generally depended on the mass market and the avoidance of anything artistically unfamiliar and challenging.

This is not intended to be an argument for a return to archaic techniques, still less for a privileged view of art or intellect cut off from practical activity. The tiniest revelation of 'actual life' on TV or in the newspapers is preferable to any amount of pseudo-art. Wherever they are economically available to independent people, photography, film and TV

have always been used in an oppositional and subversive sense. A large part of the subversive effect lies in showing up the contradiction at the heart of the mass media as a social institution: the way in which the media are experienced as both *close* and *remote* at the same time. They penetrate everywhere but make the world visible within the strict terms of a dominant ideology. Curiously enough, this description is very similar to the dictionary definition which Walter Benjamin quoted for the 'aura': 'Distant, however close it may be.' By contrast, the popular expressions in this book are the embryonic images of a movement by groups of people all over the world to make themselves visible in their own terms, to represent themselves. Their efforts are directed both in the sphere of *action*, by breaking the silence and taking back their own history from remote authorities; and in the sphere of *style*, by picturing the world in various ways which challenge the Renaissance supposition of a detached, 'objective' individual with an 'omniscient overview of society'.

If these movements can be seen partly in terms of a struggle over the issue of representation, the contest is of David and Goliath inequality. Poor means, crude technique, powerlessness and localization on one side, set against the global operations of the mass media, with their huge resources and complex processes in visual and verbal selectivity to remould reality to fit stereotypes and discredit any questioning of the status quo. Images on discarded flour sacks to set against electronic news-gathering. Sometimes an opportunity arises to compare the two expressions directly. The Shaba paintings, for example, come from exactly the same area of Zaire where, in 1977, the FLNC (Congolese National Liberation Front) led an unsuccessful uprising against the central government of Mobutu. This event was generally presented by the mainstream Western media as an 'invasion' of Zairean territory, hugely amplified by lurid stories of the massacre of Europeans by Africans. Copper-rich Shaba province is the focus of all the contradictions of Zaire: source of the country's wealth, much of which is siphoned off by the presidential clique; area of intense foreign investment and management; site of the shanty-towns of African workers who have migrated from their ancestral villages, and to whose new urban culture the paintings belong. If these paintings had been widely known at the time of the uprising it would have been harder to maintain the Eurocentric distortions. Their revelation of the state of mind and consciousness of ordinary African people explode both the despicable media stereotypes about African barbarism and 'hearts of darkness', and also the European academic clichés about the 'disturbed, aimless and degenerate existence' of African villagers who have moved into town. The Shaba paintings show the people have a consciousness of their history which is not only rich and detailed, but also *theirs*: a sense of mythical origins, and of traumatic past events, which illuminates their

21

present struggles and predicaments, in the framework of a concept of time different from the European. One painter, Tshibumba Kanda-Matulu, has produced an entire history of Zaire in more than one hundred paintings. The highly popular *colonie belge* genre of Shaba painting (see pp 92-95) exists in dozens of variations by individual artists which all conform to the same iconographical pattern. The variations themselves underline the strength of the image, which is a concise and crystal-clear summing-up of colonialism, its power relations and its impact on an entire people. Once it is possible to see from this perspective, from this self-representation by the many, it is the media stories that become the mystificatory and bizarre fiction.

The Shaba paintings can only be contrasted with the media version of reality by implication. This was no part of their purpose. But in the case of Greenham Common it appears that the women protesters were conscious of the media from the beginning. Their efforts were first of all to gain media attention, and then, when the journalists and photographers descended overwhelmingly on this patch of countryside, to distinguish carefully between local and national press and TV, the various foreign national networks, and the alternative and oppositional media, and to respond to each differently. Finally, their effort was to create their own communication systems. The typical traits of the official media – searching for a 'leader' from whom to get a definitive statement, playing up anything to make the protesters seem menacing and 'other', handing out the truth from a position of superior wisdom – probably sharpened their perception of a completely different way of communicating with those outside. Using their own weakness as a source of strength and new values, they publicized their projected action for 12 and 13 December 1982 by means of the chain letter. As Alice Cook and Gwyn Kirk commented:

22

> Each woman was asked to copy the letter and send it to ten friends who would also copy it and send it to ten more, so everyone was part of the organizing. This was an inspiration for many women, giving them a chance to participate on their own terms. Responsibility was not in the hands of a central organizing body, but focused on each woman responding to the invitation ... It seemed at the time as if we were plumbing older networks of talk and rumour, and discovering how efficient a means of communication they are. If the information strikes a chord, it is transmitted.[13]

The chain letter belonged to the same metaphor as the other actions which marked those two days: weaving webs out of wool, embracing the missile base by joining hands around it and closing it, and decorating the perimeter fence with objects and images of personal importance which

people had brought with them: a political demonstration which was also an act of collective self-representation.

In another action a year later, women at Greenham Common held up mirrors to the soldiers guarding the perimeter fence. To individual soldiers funny or embarrassing perhaps, but in this gesture the eye of authority, accustomed to survey the word, was turned back on itself. This whole complex of ideas – objectivity, surveillance, the omniscient overview of society, the perspectival system of representation, the 'eye of power' – is implicitly challenged by the popular expressions in this book. It is quite fascinating and remarkable to find stylistic traits in common between images produced far apart in space and time, in response to very different circumstances, by groups who can have had no direct contact with each other. There are striking similarities in what they choose to emphasize and how they compose their images. Things are not arranged from, or for, the individual viewpoint, but for that of the group. Instead of the world in the image 'radiating from one individual and returning to that individual along the lines of geometric projection', things are arranged without hierarchy as a network of interrelated events. The artists are less concerned with building up an arresting effect than with including everything of importance in the image, so that it is closer to a map which has to be carefully read than to a rhetorical expression.

The paintings from Zaire, Chile, China and Hiroshima are nearly all variations on a type of 'landscape with figures'. As a format it can be taken to stand for the World, allowing the artists to give equal importance to relations between people, relations with the environment and nature, and with human-made artefacts of whatever kind. Both the Huxian paintings and the Chilean patchworks include a great mass of everyday material detail. Whereas in the Chinese paintings it is connected with improvement and development (new tools, books, electric power, clothes, irrigation systems, sports and abundant crops), in the Chilean images it is connected with the struggle for survival (food prices, cutting off electricity, unemployment or subsistence work, police brutality, garbage, flies, sickness, the necessity of neighbourly solidarity, and so on). This does not prevent an electric light bulb, or for that matter a playful child, being picked out with the same enthusiasm in China and in Chile. In the Chinese paintings people are not individualized by features or psychology, but they are highly individualized by gesture. Over and over again the artists try to integrate work and leisure in a kind of composite gesture of conviviality (see for example *Spring Hoeing* by Li Feng-lan, p 62). In the same way they integrate landscape as a composite of production and pure pleasure. It is by the flow of interrelated gestures that the painters convey individual identity as part of a group.

In the Hiroshima paintings, the specific details of individual memories

23

interlock to produce the experience of an entire citizenry. It is impossible to imagine anything that could better bring home the meaning of nuclear attack for the man, woman, child in the street.

As well as their precisely observed factual detail, many of the images contain elements of desire or dream. In the Chinese paintings the references to fact and fantasy are closely interwoven, perhaps because the dream is (or was) a continuation along a road already mapped out. The quality of élan seems to be a merging of both. In the Chilean patchworks the dream is a compensation for present miseries and appears both in imagery – birds, sun, mountains, symbols of hope – and also in the wonderful wit and pleasure the women take in reprocessing waste materials as pictorial signs. The Zaire painters have presented themes of desire as a separate category of picture, the *Mamba Muntu* or mermaid (see p 96), and in a different mode, the mythological. Perhaps this is because of the ambivalence surrounding personal success and failure in a society moving between traditional kinship obligations and the individualism of the big city.

The Zairean, Chilean, Chinese and Japanese pictures are mostly narrative in form. The spinning of webs of wool or the decorating of the perimeter fence at Greenham Common are popular expressions which, as suggested earlier, are consciously or unconsciously linked with developments in avant-garde art. The webs are very close to ideas of participation and performance art about the workings of metaphor directly in everyday life situations. The fence was a giant 'collage', producing a new meaning from the combination of mass-produced objects and imagery. Yet the collective form of production cuts across these differences of cultural context. The Greenham fence was literally made up of the individual contributions of thousands of people. The Huxian paintings go through several stages of enrichment as other peasants suggest to the painter important details he or she has left out. The Chilean patchworks are produced by individuals working in a group who come to an agreement on the theme to be treated and exchange materials and ideas. The Shaba painters do not set themselves apart as 'artists' but closely identify themselves with their audience for whom they make their pictures as 'reminders'. If they worked individually, the Hiroshima artists were united by a shattering experience from which 'detachment' was impossible. Therefore in all cases the pictures have functioned not as passive depictions of reality but as generators of the consciousness and cohesion of the group. They take the 'we' view, from within society, and do not pretend to look upon it from outside.

24

●

By making society the concrete and the individual the abstraction, these pictures reverse a pattern we in the West have taken for granted for centuries. But if this is the real novelty of such images, their newness is also paradoxically mixed with the old-fashioned, even the ancient, in ways which underline the complexities of cultural interactions in the world today.

For the Huxian artists and their peasant audiences, the paintings represent all that is new and changing. But for Western city-dwellers there must be a certain nostalgic appeal in the quaint machinery, and the minutely tended fields full of people, which throw us back to medieval tapestries and Books of Hours. African shop signs, whose purpose is completely utilitarian, depict objects and commodities in direct, full-hearted ways which to Westerners can only recall the lost innocence of the early days of consumerism. The appeal of naivety itself is delicately stretched between the vigour of what is new and emerging and the refinement of what is old and privileged.

The disparity in consciousness between metropolitan consumers of this art and those who may produce it, such as shanty-town dwellers in Chile or peasant farmers in China, is a phenomenon with two sides to it. It can either feed a sentimental neo-primitivism, fashions and lifestyles which are an expression of affluence and therefore can only be blind to the real needs of populations in the Third World. Or this disparity can have an enlightening effect of showing that the structure of the world is changing in ways which have the potential for creating a radically different future.

Formerly, all the most powerful contemporary realities were bound up with the image of the great Western city: wealth, power, industry, modernist culture, the masses, revolutionary opposition. But the accelerating movement of people, objects, images and words about the world has producd a much more fluid and shifting relationship between the particular locality of an event and its global implications. Since the Second World War both superpowers have moved further towards creating their own forms of an international division of labour. The capitalist powers have not only arranged the migration of millions of people from Third World countries to their metropolises in order to do the most menial jobs, but now increasingly hire and fire labour in those countries themselves. Along with their goods they have exported the Western capitalist culture and lifestyle to every part of the world to give increasingly the appearance of a single global culture. But at the same time this internationalism has been challenged by the internationalism of the anti-imperialist liberation movements which have taken advantage of the same global process to attack the assumptions of Eurocentric ideology, not only in the Third World but in the Western metropolises themselves.

Formerly, even socialist thinkers had seen an international democratic

culture of the future as essentially a prolongation of the European bourgeois tradition, which seemed to be synonymous with civilization and progress. But the rise of Third World peoples has made visible other perspectives, human values, 'a different hunger'.[14] The narrowness of European norms, and their inescapable association with the heartlessness of imperial power, has been challenged by those who have struggled to make known the vast but hidden heritage of precapitalist folk, popular and communal forms of culture produced by groups of people all over the world. The physical presence of Third World peoples in Western metropolises and their identification with liberation struggles in Africa, Asia and Latin America, combined with the growing inhumanity of industrial society, has sharpened the critique that these very different, and apparently 'older', forms can make of the status quo.

Dreams and images of 'community' therefore acquire a new force. Art movements like those in this book seem to have a 'natural' opposition to the ideas of art associated with capitalism: they emphasize the individual as part of the group, they allow that everyone is potentially an artist and can give form to their feelings and ideas. They consider the art work not as a commodity but as a sign, a communication, which is efficacious in other areas of life, such as production, or the healing of psychic trauma. At the same time they are not museum relics, or forms of popular culture conforming to prescriptions handed down from above. They are provisional, rudimentary, hybrid forms where people were moved by events to represent themselves and their experience in the face of silence.

To respond to them is not to deny their elementary artistic level, or to put them on a plane with advanced and highly evolved works of art. They cannot be treated in a prescriptive sense, as a model for the professional artist to imitate, whether these be concerned artists who are aware of the content of the pictures or cynics who want to exploit their oddities of figuration for expressive *frisson*. They are signs of a point where the artistic impulse in all its facets meets the overpowering realities of life for the great majority of people in our period. In a sense all artists have to face this same meeting point and decide how to respond in terms of their own work. Particular forms do not have to be judged and compared at the expense of one another. Every form must begin at some place, and then may develop or regress. In the end the proof of a popular culture lies in its vitality, a vitality which always brings together the sharpest observation of the present with the intimation of a future free of every form of overlordship – including the artistic.

26

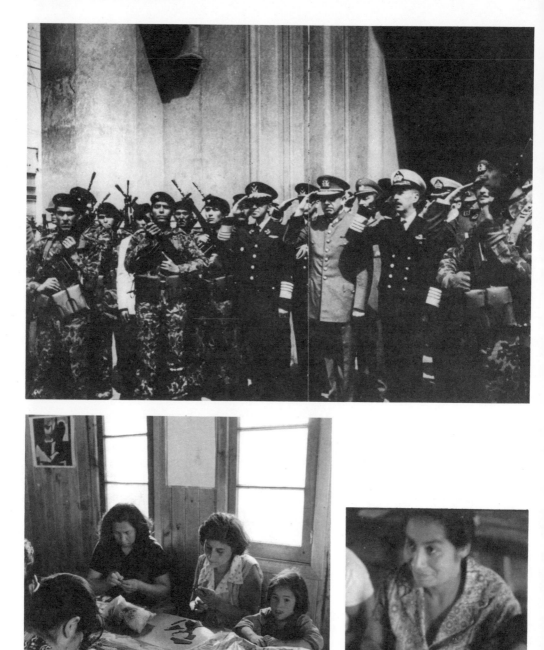

CHAPTER 1

ALL THIS WE HAVE SEEN

They gather in the church hall, or another building which is more solid and spacious than the shacks of the shanty-town. There are ten or twelve women. They sit around a table heaped with off-cuts and scraps of material collected from textile factories, balls of wool, and square pieces cut from flour sacks. A stray dog wanders in and out. Children kick a ball in the dust outside; younger ones sit with their mothers on the bench. A kettle is boiling on a camping-gas ring in the corner. As they sew the talk ebbs and flows: about everyday problems of getting by in conditions of near total unemployment, about the latest populist gesture by the military government which most know to be phoney, about their plans and fears for the next monthly day of national protest. The talk is laced with humour, but faces darken as somebody mentions a woman they all know well who was found drowned in a water-filled ditch, unable to endure her hardships any longer.

After a while, one woman finishes stitching onto her patchwork a long loop of black wool which stands for an electricity cable, and holds up for the others to see her version of the theme all have agreed to embroider that week: a local meeting to inform the authorities of their refusal for reasons of poverty to pay for water and electricity.

Groups like this in the poor areas of Chile's capital Santiago have produced thousands of patchwork pictures (*arpilleras*) in the last ten years. All are based on the startling dichotomy of a childlike, innocuous, 'toy town' form used to give expression to the direst realities which face the mass of people every day in most countries of the Third World. From these thousands of images a complete and detailed chronicle could be made of the experiences of the Chilean working class since the brutal military coup of 1973.

In conditions of great insecurity and hardship, groups of Chilean women have sewn thousands of patchwork pictures showing the realities of life under the military dictatorship which seized power in the coup of 1973.

A typical patchwork measures about 33 by 47 cms, and is made of scraps of waste cloth and wool on a backing cut from flour sacks.

29

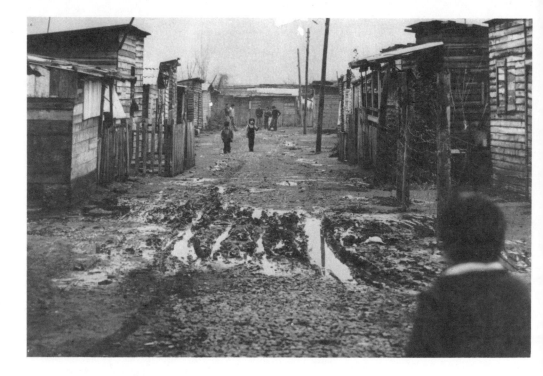

Chile: a society brutalized.

30

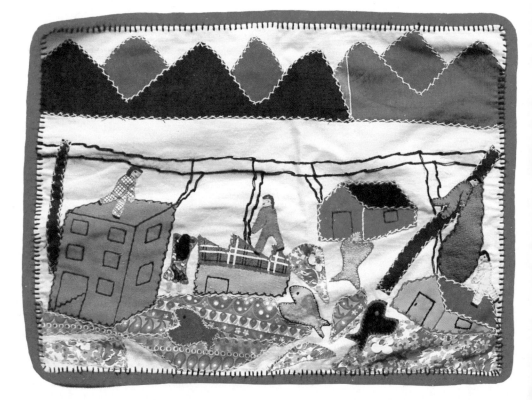

How did such an artistic phenomenon come into being?
Conditions after the coup were hardly auspicious for any
kind of creative activity. But the remarkable thing about the
arpillera movement is how closely connected with recent
events in Chile it has been, and how near the pulse of
popular feelings both of despair and of resistance.

●

Chile is not a country of great strategic importance in terms
of its geopolitical position and natural resources. But, as has
been pointed out many times, it has aroused world-wide
interest in the last fifteen years for the intensity of the
political/social/economic experiments it has undergone. On
the one hand Chile has the typical characteristics of a Third
World country: an economy at the mercy of the market
fluctuations of one commodity (copper), indigenous
industries stifled by foreign multinationals, a small
privileged elite and a mass of oppressed people many of
whom have moved to the cities in search of work and live in
shanty-towns on their fringes. But Chile also has (or had)
many characteristics of a developed country: a large middle
class, long-standing civic and parliamentary traditions,
educational and welfare programmes, high literacy, and a
conscious and organized working class. This combination
of elements produced a class struggle of extraordinary
intensity and drama, as Chile moved from a period of
liberal Christian-Democrat government in the early 1960s,
through Salvador Allende's 'democratic transition to
socialism', to the military regime's monetarist free-market
economy imposed by fascistic terror and repression. Sectors
of society which had formerly led an uneasy but fairly
stable coexistence – not only the social classes but also
semi-autonomous 'societies within society' like the church
and the military – confronted one another in a thousand
incidents: some glorious, some tragic, some both ludicrous
and terrifying at the same time. A widespread popular
movement for change has underlain this whole period. Its
strength is testified to by the obsession of the military with
giving back to Chile (or at least the centre of the capital city)
an appearance of the kind of humdrum civic normality it is
supposed to have always possessed. Regions, classes,
professions, groups, even individuals have been atomized
and sanitized from one another in a characterless frozen
status quo. It is a chilling experience to stand in the new
Santiago metro or one of the manicured public gardens
(both cleaner and neater than anything in Britain),
knowing the murders, tortures, mass evictions and
harassments that lie behind them. Knowing too the real

destruction by the military government of the country's economic and social infrastructure built up over a century, and the means of livelihood of most of the population.

The ordinary people of Chile faced therefore after the coup an overwhelmingly adverse situation. Many had lost friends or relatives – killed, or vanished in the even worse trauma of the 'disappeared people'. Censorship was omnipresent, political activity of all kinds was banned. The junta's economic policies led to mass unemployment, and cut off public funding for health care, housing, education and so on. Hunger faced the families of workers and shanty-town dwellers. Against this, on the positive side, there were really two factors: the considerable level of political consciousness and cultural aspiration of the people which had been growing over a long period, and the position of the Roman Catholic church which did not identify completely with the new regime and became a centre for emergency assistance of every kind.

The emergence of the *arpilleras* is intimately tied in with all these events. Some precedents existed in local folk art. There was a tradition of decorating bags and baskets, and of pictures made of coloured wool by a community on Isla Negra, whose work was admired by the poet Pablo Neruda and the folk-singer Violeta Parra. But there was no direct connection. Although it is hard to be absolutely precise, *arpillera*-making probably had two separate points of origin. One was among the mothers and grandmothers of the (mostly young) people secretly seized by the DINA (secret police) and rarely heard of again. These relatives used to go frequently to the church office of the Vicaria in downtown Santiago, the only place which would offer help and legal assistance in their frustrating search for information, and by regularly meeting others in the same situation they gradually formed themselves into a protest group, the Families of the Disappeared. The other point of origin was among the women of the shanty-towns whose husbands were unemployed and whose families faced starvation. The church assisted them in setting up laundries, simple workshops and soup kitchens. For both these anguished groups *arpillera*-making was a kind of therapy. They have often spoken of the relief of finding this means of expression. For the second group it was also from the beginning an absolute necessity for survival. The church bought the *arpilleras* for small sums, distributed and sold them, first in Chile and later abroad.

There's one *arpillera* I'll never forget. I made it at the end of 1975.

'El Gordo' [her husband] had lung trouble, in fact

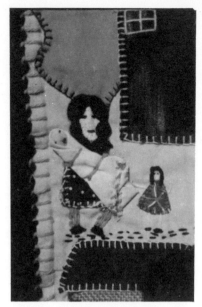

The working-class women who make the patchworks live in the shanty-towns on the fringes of Santiago – squatter settlements which they struggle to improve. Amenities are always precisely detailed: electric lighting (often hijacked from overhead cables), toilet (with flies), water-tap (with queue), furniture. The progress gathering pace during the Allende years was drastically reversed by the military. Here the men sit around without work, a child is sick, a woman faints.

Chile in the year following the coup. Mass detention of political prisoners. Relatives arrive at the prison gates carrying parcels. Inside they embrace their loved ones. But another prisoner is in solitary: 'How sad I feel!'

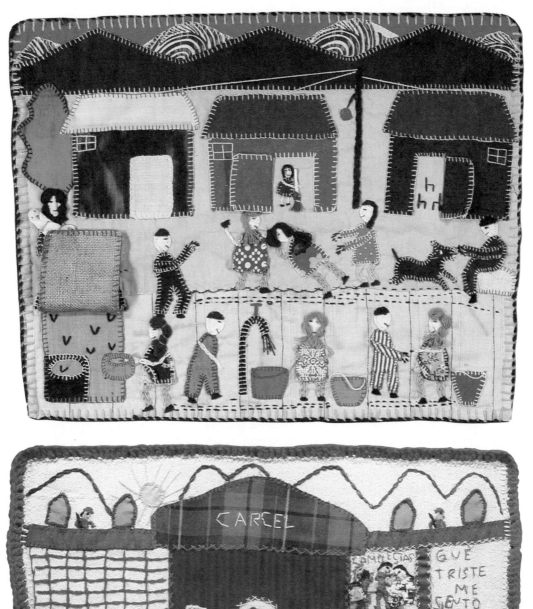

he had cancer and he had to go to hospital. I was left
with the kids. My boy, who was about ten then, asked
for something to eat and we just had nothing to give
him.

It was such a big problem for me, I felt impotent, I
didn't know what to do. I decided to vent my feelings
by making an *arpillera*. I made a road which went up
into the mountains and had no end, then I made a sun
which I gazed at and it gave me strength. This sun I
made from pure red wool.

When I tried to sell it I couldn't. How could I sell
this *arpillera* which was so much 'me'. How was I
going to do business with my own life?

In the end, after a while, I gave it to a nun.[1]

It would be wrong to think that the process was easy or
simple. To form any kind of organization, to get together at
all in Chile after the coup was dangerous. There was not
only stark fear to overcome. The junta was spreading an
ideology of consumerism and individual competitiveness,
even among the poor. And then there was the traditional
Latin male chauvinism. Many women became involved, to
begin with, only from dire necessity. But as the movement
spread, its therapeutic function changed to one of conscious
communication, not only with one another but with the
world outside. Many believe that the revival of popular
organizations in Chile and their first great boost at the
demonstrations of 1978, which moved public opinion so
much, came partly at least from the meetings of the
Families of the Disappeared and the shanty-town dwellers
for the purpose of making *arpilleras*.

It was hard. We came to the meetings because we had
to work together, but the men wouldn't let us go out. I
was clouted a few times. I was given black eyes. But I
had to earn something so that we could eat. Later I
began to enjoy the work because I learnt new things.

I'll never forget those meetings which we had once a
month, where 80 or 90 women got together, all the
arpilleristas of the zone. It was such a great joy to see
and talk with all those people, and to look at the
themes of the pictures and analyse them. Unfortunate-
ly not everyone could come because of the cost of
transport.

With this work I learned to grow as a person, to have
an opinion, to criticize, to understand. Women are at
home, just keeping everything going. They don't

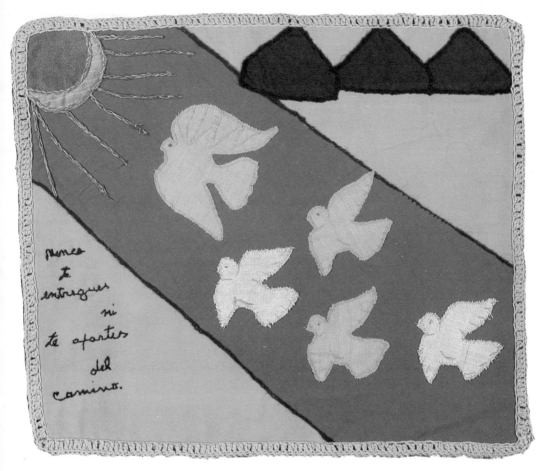

'Never give in or stray from the road.'

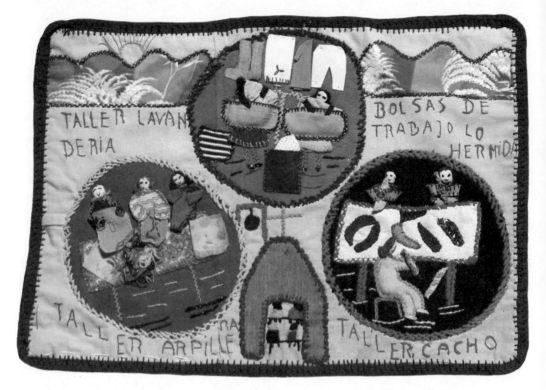

Three kinds of popular workshop set up with church aid to provide a minimal income: arpillera-making, laundering, carving in horn.

know how to do anything else, people who are just physical, and in the head, nothing.

●

For most of the women patchwork-making is valued for two essential reasons: it can bring some money to their homes, and it can carry a message to other parts of the world. The women cannot afford to keep any patchworks for themselves, or to give them to friends; their sale is a life and death matter. Nor can the women themselves afford to move, barely even to the city centre. They are rooted to the spot, but their message can travel. For these reasons the workshops are carefully organized and production is controlled. Usually the women in a group make one patchwork each a week. An intermediary, either from the Vicaria or some independent organization, brings plastic bags full of jumble and rags and takes away the finished work. The money from sales is distributed by a treasurer and a proportion kept back for buying materials and for emergencies. The themes for the patchworks are decided by discussion and the finished pictures are also looked over and analysed, to see that they are well made and that they really 'say something'.

The 'chronicle' on pp. 38-43 can give only a limited idea of the number and pertinence of the themes treated by the *arpilleristas*, and even less idea of how each theme is interpreted by different individuals. Some pay great attention to realist detail, others are more subjective and dream-like. Some stay close to the specific experience, others try to synthesize and sum up events and make visible the underlying causes. From the beginning the women introduced symbols and codes, both as a form of compressing ideas and as a means of deceiving the censorship (to depict the junta directly was to put oneself in mortal peril). In some of the finest patchworks these work together: in the 'cool' emblem of economic exploitation, for example; or in the circus picture which brilliantly mixes innocuous charm with sharp satire.

37

Patchwork back: irony and euphemism.

CHILE 1973-1984 — A PATCHWORK CHRONICLE

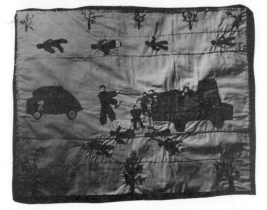

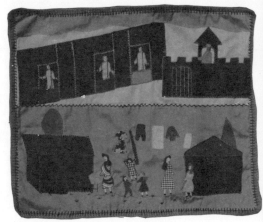

The day of the coup, 11 September 1973. The streets of Santiago. Dead civilians are thrown into a truck.

The world split in two. Political prisoners at the bars of prison cells. Their families in the shanty-towns have to go on with life.

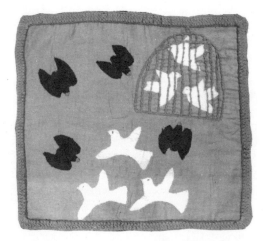

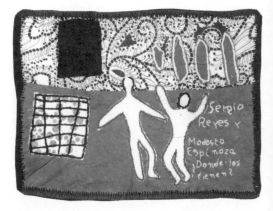

38

A symbolic form of the same theme. The four vultures are the four-man junta which took power in 1973.

Made by the mother of one of the people shown in it, who were detained together. The four vertical strokes at the top right stand for Quatro Alamos (Four Poplars), a secret detention centre. The black square to the left stands for some unknown place, the anguish of knowing nothing: 'Sergio Reyes and Modesto Espinosa – where are they?'

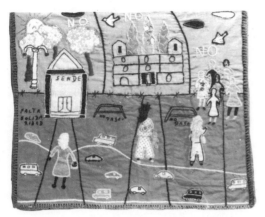

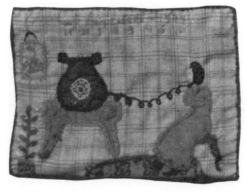

An endless and futile search for news of relatives 'disappeared' (ie. abducted or murdered by the military and secret police) in the aftermath of the coup. They go to the SENDE (National Secretariat for Detainees); to Tres Alamos prison (always denoted in the patchworks by three poplar trees); to passers-by. The answer is always 'No'. Feeling her powerlessness, the artist has stitched on at the left: 'We lack solidarity'.

Day after day on the telephone, hoping for news.

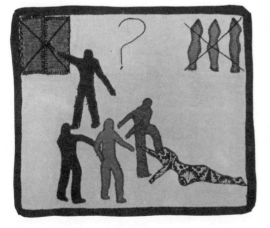

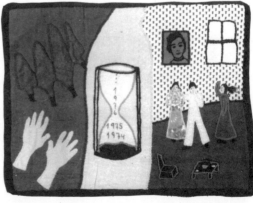

39

Torture. The prisoner will not be taken to Tres Alamos, but to some unknown place.

Three years missing.

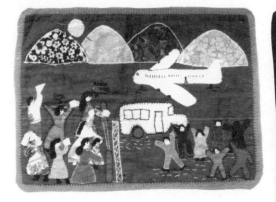

Some prisoners are released, but only for immediate deportation and exile.

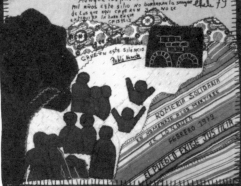

In November 1978, following a confession to a local priest, fifteen bodies were found in a disused lime quarry at Lonquén, 32 miles south of Santiago. All the bodies were those of people detained or abducted in the aftermath of the coup. This discovery became a turning-point, since it forced the military government to admit its implication in the disappearances, which until then it had repeatedly denied. This patchwork depicts a pilgrimage to the mine in 1979, adding some lines of the poet Pablo Neruda to the effect that thousands of passing feet will never wash away the blood.

40

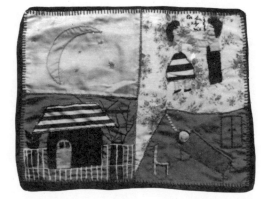

A mother dreaming of reunion with her missing son: 'At last my darling…'

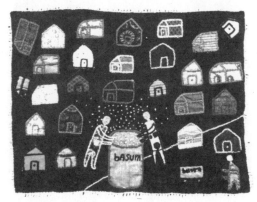

Conditions are so bad, people have to search the dustbins for food.

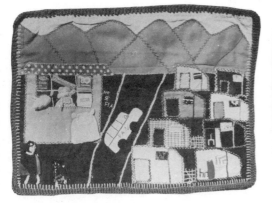

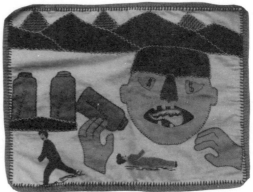

'No se fia' – 'No credit'. Before the coup, shops like this extended weekly credit and people could settle after pay-day.

Capitalist greed.

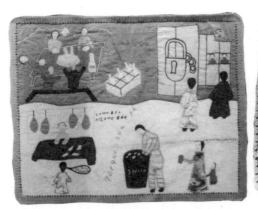

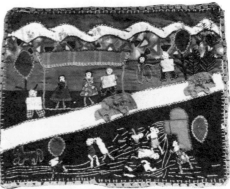

41

Rich and poor. With the high price of meat, many people can only afford 'half a kilo of bones'. 'Why are the bad people happy?' It is the rich who have locked up the children of the poor.

The split world of Chilean children.
Below: playing in a fire hydrant.
Above: selling sweets to occupants of passing cars.

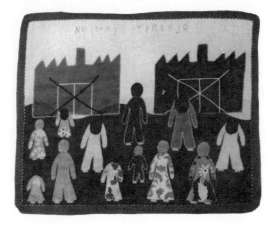

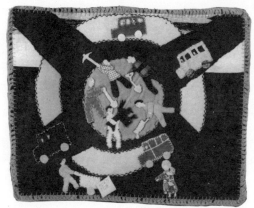

No work.

Or meaningless toil tending road verges and manicuring parks for starvation wages on the PEM, the government's minimum employment programme.

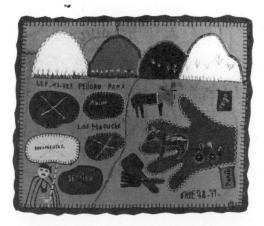

42

The situation of the Mapuche Indians, descendants of the original inhabitants of Chile, who live in the south of the country. After progress in land reform under Allende, military 'decrees' have returned land, cattle, tools and crops to the big landowners (red hand), leaving the Mapuche with nothing.

A recent patchwork exposes a brutal crime perpetrated by agents of the CNI (secret police) which took place in May 1984. The military authorities claimed that a young woman, Maria Loreto Castillo, had died while planting a bomb underneath electricity pylons. The patchwork depicts the truth as later revealed: she had been arrested by the CNI, beaten senseless with an iron bar, and then blown up with dynamite. Facts and feelings are inseparable in this art form, and nothing could show this more clearly than the device of the hands offering flowers. The way these flowers are thrust towards the victim, as if from a human world outside the dark incident, the bright points of the flowers and the decorated sleeves, all of which contrast sharply with the black, creeping figures of the CNI, show the intensity of popular feeling against such acts. This gesture which is depicted here is really the same kind of action as the sewing and making of the patchworks themselves.

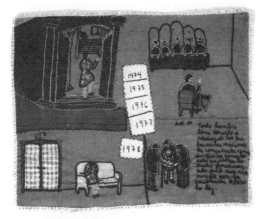

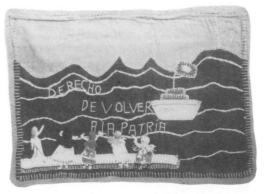

Demanding the right to a fair trial under article 8 of the UN Declaration of Human Rights.

Demanding the right of exiles to return and live in their own country.

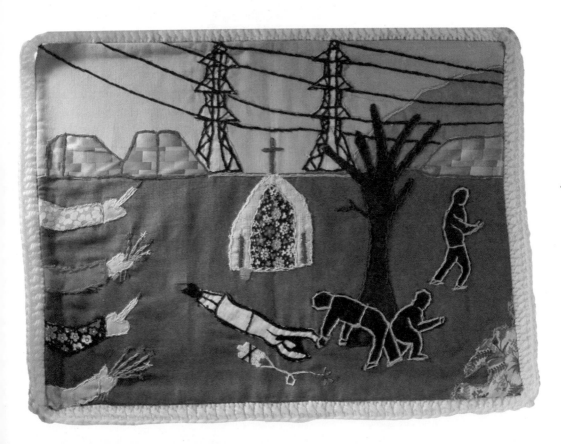

43

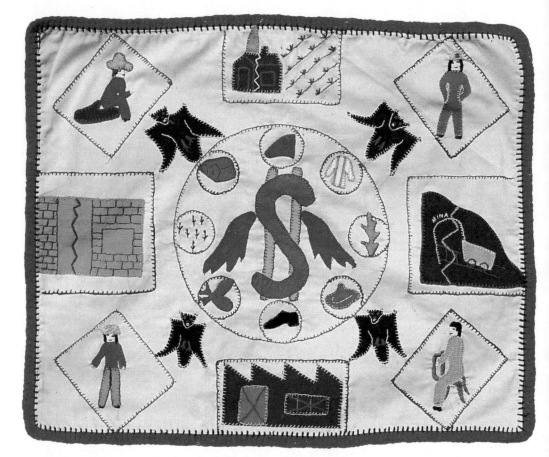

44

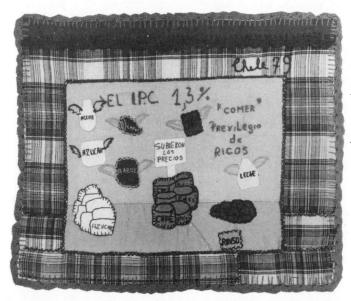

Patchworks conveying complex ideas through a witty use of code. The economy of Chile. The different workers and the main areas of production around the edge: agriculture, mining, industry and construction. Inside, Chile's main products: clothes, shoes, fish, foodstuffs, copper, etc. There's no work (the zig-zag lines) and all the wealth flies out of the country. The four bats are the four members of the original junta.

Rising prices: oil, sugar, rice etc. 'Eating: a privilege of the rich...'

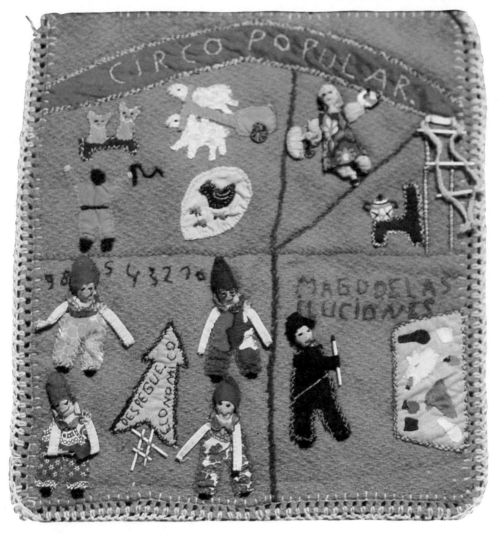

In this 'popular circus' the Chilean people are put under the lash (top left); the four clowns of the junta show off their phoney economic boom (bottom left); a conjurer pretends to make food appear out of thin air (bottom right); and (top right) a housewife with her shopping bag treads the tightrope of survival.

45

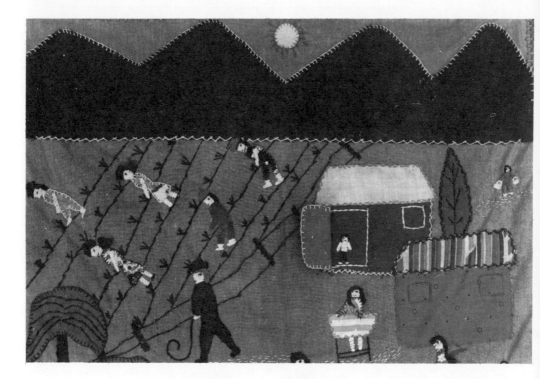

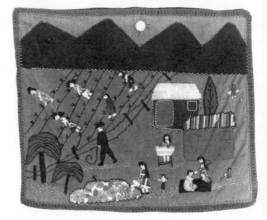

46

Other codes are literally uncensorable because their meaning is on the one hand imperceptible to the fascist mind and on the other a powerful source of encouragement and·hope to those with humour and humanity. The basic concept and setting of these scenes, so consistent over the years, forms one of these codes. Whatever the main subject of the picture may be, it rarely appears in isolation. It is almost always integrated into a network of detail which is not incidental, and also into a kind of continuum of consolatory signs. The soup kitchens (pp. 48-49) are shameful, representing a disastrous about-turn for a people who had begun to see significant progress. But they are a necessity both to feed the children and as a place to meet. Here, as in pictures of laundries, details like gas burners, food, taps, kitchen utensils, washing powder, irons, etc. are shown precisely. By the constant role given to them in the changing and often tense events of each picture, the familiar things of everyday life take on a symbolic role. The playfulness of children is another coded sign. Another – the most persistent of all – are the mountains. The Andes, towering over Santiago and running the whole two thousand mile length of Chile, are both the most obvious feature of the landscape and also the symbol of grandeur and promise against which to measure the cramped, grinding existence imposed by the present-day social system. This relationship of temporary events to the ever-present mountains (sometimes with the sun rising behind them) is perhaps the outstanding invention of the *arpilleristas*.

Another message of resistance in the patchworks which cannot be removed without destroying them physically is of course the whole way they are made. This again is a curiously subtle phenomenon. Some of the pictures could be taken as merely charming and naive if one did not understand the subject; and some people, understanding the subject, find it hard to reconcile this with the obvious care and enjoyment taken in the use of materials. But this duality is important. In the patchworks women can show injustice and sorrow with great exactness and truthfulness, but not allow their life and wit to drain away to the rigidity and coldness of their oppressors. It becomes part of one's conception of oneself as a human being to use all the art one knows and to bring out the hidden qualities and beauty in the scraps of mass-produced material, a fact which is instantly recognized and magnetizes people to the patchworks, wherever they are shown.

47

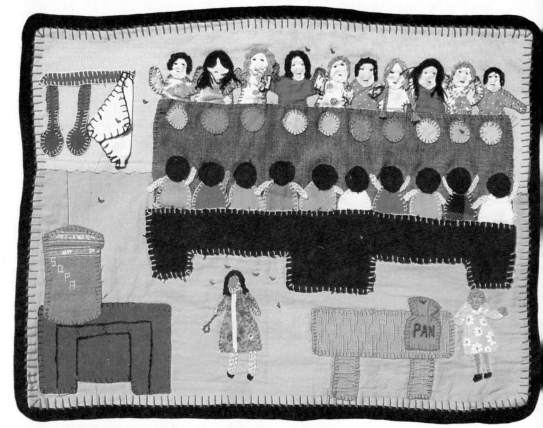

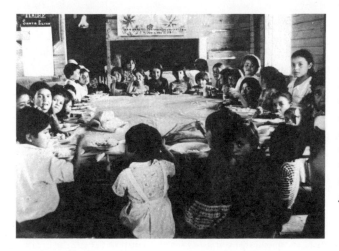

The moving double meaning of the comedores, or soup kitchens. A source of outrage, a regression to conditions of poverty unknown for fifty years, they are also a necessity to feed the children and one of the few safe places to meet and talk. Each person interprets in their own way the communal table, the playfulness of children, and blows up in size the things of importance: food, cookers, gas, electricity.

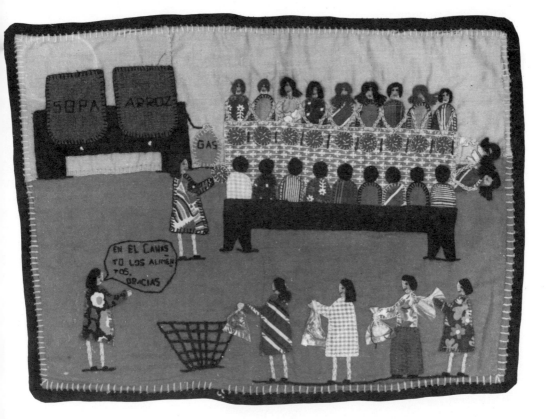

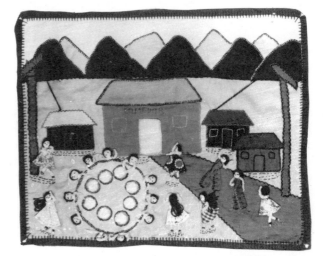

Apart from all this it's a great joy that people consider that we are making art, that we are artists in this. For us, as housewives, we've never been, or dreamt of being, artists or working in that sort of thing. In this there's some compensation for all that's happened. It gives us more strength to go on, to go on struggling to live. God willing, we'll be able to make them better every day.

Some patchworks show the contrast between the houses of the rich and the houses of the poor. Houses have considerable cultural importance in Chile, for all classes. Beyond a question of respectability, people put a lot of love and even a personal sense of poetry into their houses, yards, gardens and their forms of hospitality. The old port city of Valparaiso is a fantastic flora and fauna of every conceivable realization of the concept: house. (Pablo Neruda was also someone who loved and celebrated houses.) As depicted in the patchworks the shacks of the shanty-town are both a source of outrage (in one the single toilet for the whole settlement is shown, full of flies) and a source of pleasure: the way such details as a tree, a fence, a vase of flowers are included is a resistance against dehumanization. For all their poor materials, these are a rich form: rich in colour, rich in texture, rich in wit. They are like not burdening the other person, but making the best presentation of oneself, one's house, one's hospitality – something very deeply rooted in Chilean culture.

●

All this has tended to confound the Chilean authorities for an appropriate response. Occasionally shipments of *arpilleras* have been seized at customs, and in 1978 a pro-government newspaper, *La Segunda*, carried a two-page attack headed: 'The Tapestries of Defamation'. The authorities have been well aware of their critical content but have usually directed their attack at the church. The patchworks are never signed. The most they carry is a small handwritten note by the artist explaining the picture, folded into a tiny pocket at the back. If these had been a more conventional agitational form, such as posters, the response would have been very different (members of a graphic poster workshop were detained and sent into internal exile as recently as 1983). But since the patchworks are labelled as *artesania* (crafts) and are produced by people whom the junta presumably sees as poor ignorant women, the flow has never been seriously interrupted. Through the

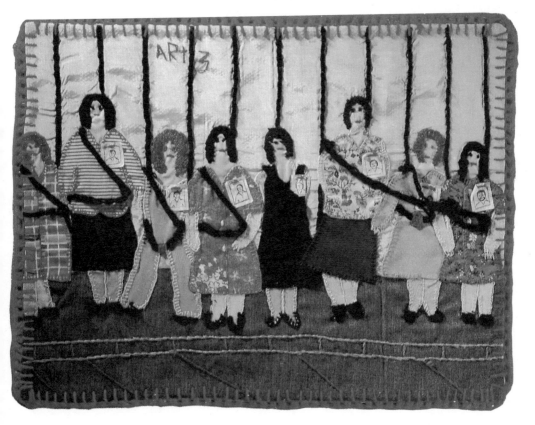

*Braving beatings or death, mothers
and daughters of 'disappeared' people
have several times chained themselves
to the railings of the National
Congress in Santiago to demand a full
enquiry and punishment for these
secret abductions. Photos of their
relatives are pinned over their hearts.*

51

networks of the church, solidarity and human rights organizations (rather than the art world) the *arpilleras* have achieved a remarkably wide circulation all over the world.

A greater controlling factor than the Chilean military, in fact, has probably been the intermediaries and 'patrons' of patchwork-making itself. Their role has always been important since the *arpilleristas* are not in a position to sell their own work. As the movement has spread, and as the political situation in Chile has developed, the motivations of intermediaries have diverged. The church has increasingly tightened its control over the content of patchworks in those groups which it manages. In the last few years it has asked the women to embroider generalized themes, such as the articles of the UN Declaration of Human Rights (the visual interpretations made of these can still be highly pertinent). And there has been a natural tendency to supply the market with a few well-established themes, such as the soup kitchens. But other intermediaries have been concerned to evolve, with their groups, the vital relationship the *arpilleras* have always had with reality as it changes. A criminal act of repression will always be exposed, but simple denunciation for the patchwork-makers no longer seems enough as the opposition to Pinochet grows. In the last few years they have been turning their attention to longer-term issues which will persist no matter what government may come to power, such as the level of unemployment, the need for popular organizations in the shanty-towns, and even 'personal' questions such as the relationships between women and men. Needless to say, the new themes are treated with the same observation, and feeling for the whole, as before.

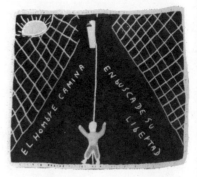

'Man walks in search of his freedom.'

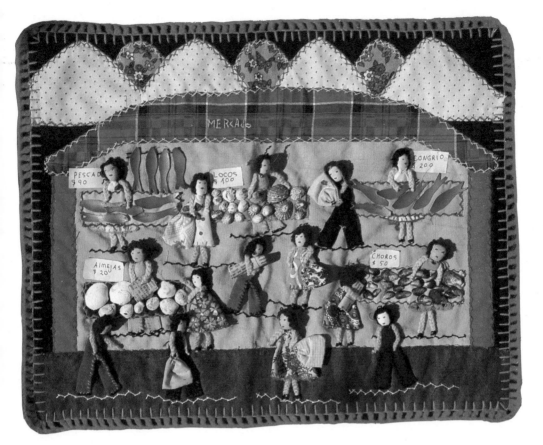

A dream of plenty, Chilean style.

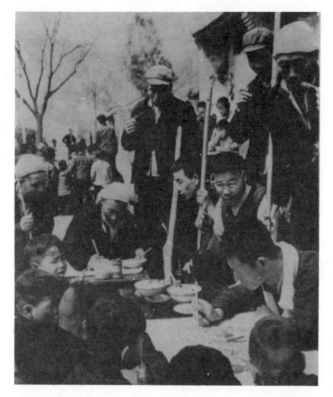

From the late 1950s on, large numbers of China's peasants took up painting in their spare time. Their paintings record, from the inside, the transformation of a land of poverty. They can also be read as a popular visual interpretation of the great debates about the true nature of a humane and creative society with which China held world attention during the 1960s and 1970s.

54

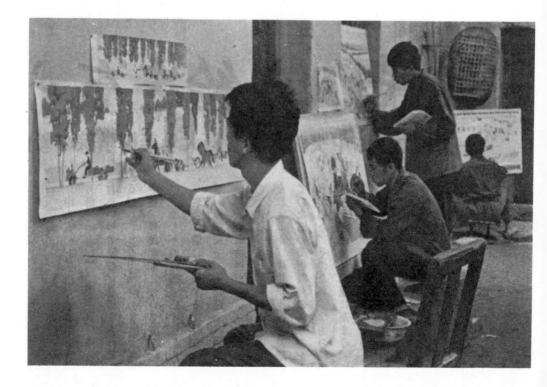

CHAPTER 2

A LESSON IN THE FIELDS

Because China has its own own art traditions thousands of years old, and because for most of its history foreign influences have been rigorously controlled, the practice of visual art in China today is particular and quite complex. Many genres coexist there. Some are still carried on unchanged in traditional form – such as the aristocratic arts of landscape painting or calligraphy, and the folk arts like New Year pictures or papercuts – but most are some form of hybrid in which Eastern and Western modes of representation mingle together and traditional techniques are combined with 'modern content'. In the period from the Communist accession to power in 1949 until Mao Zedong's death in 1976, these hybrid forms leaned towards the Soviet model of 'socialist realism' and heroic workerist imagery. Since Mao's death and the fall of the 'Gang of Four', they have leaned more towards the plurality of 20th-century Western modernist styles as a way of asserting individuality.

The Chinese art scene is not only stylistically but also sociologically complex. Large numbers of 'amateur' or spare-time worker and peasant artists emerged after the mass-mobilization movements of the Great Leap Forward (1958) and the Great Proletarian Cultural Revolution (1967-1976). They undoubtedly reproduce many of the existing styles and concerns of the professional artists, but in certain places and among certain groups, something completely new, not only in Chinese art but in the art of the world, has appeared. One such group of innovators has been the peasant painters of Huxian, a county of hills and rivers not far from the ancient capital of Xian.

Once again, a popular art movement is tied to profound historical changes by the most intimate links. The Huxian peasants have produced a 'new landscape' in both the literal and the artistic sense. Sweeping away the old landlords

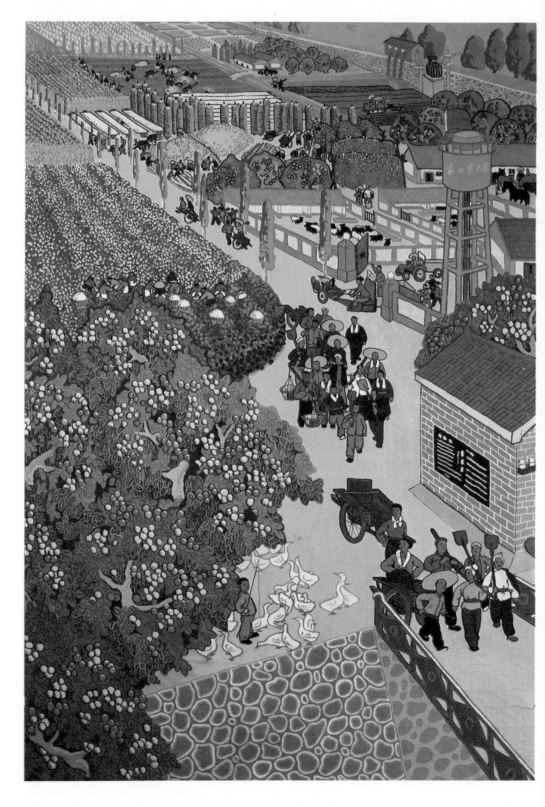

A new landscape in both the literal and the artistic sense. New Look of Our Brigade *by Cheng Min-sheng.*

after a long and gruelling war, and abolishing the feudal pattern of toiling at the point of starvation on tiny plots of land, the peasants of China, organized in new forms of association, have changed the face of the countryside. And in their paintings the land is pictured in a way it has possibly never been before in the history of art. It is impossible to confuse their images with the countryside as seen by the landlord, or by the smallholder, or by the colonial settler, or by the holiday-maker escaping from the city. They are the first landscapes painted by people who are both the collective owners and 'researcher-developers' of the land.

Painting a mural on a rural factory wall, Huxian, 1976. Photo: Guy Brett.

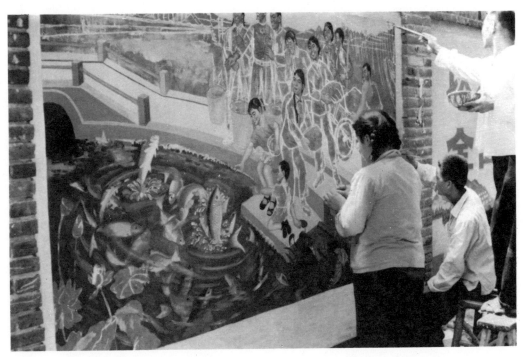

57

Actual parallels can be found, as I want to suggest more fully later on, between innovations people have made in farming technique, in social relations, in the quality of the environment, and the compositional forms they use in their paintings. On the one hand Huxian painting is a record of the superhuman effort to transform a land of poverty – a record 'from the inside', full of loving observation, morale-boosting exaggeration and good humour: the quality the Chinese call the 'brimfulness' of folk art. It can also be read as a popular visual way of interpreting the great issues with which China held world attention during the 1960s and 1970s: the possibility of resolving the age-old antagonisms between city and country, between work and leisure, and between mental and manual occupations.

At the same time Huxian painting is not a simple unitary phenomenon. It seems to contain a struggle within itself, both ideological and aesthetic. It is possible to see in the movement as a whole a conflict between real experience, leading organically to new images and new insights, and stereotypes and formulas mechanically imposed from outside. This was a problem Mao himself was very concerned with. He often advocated 'taking the peasants' own experiences and analysing them in detail', rather than 'labelling people to cow them into compliance'.[1] The paintings are part of that vital debate which takes place in any society trying to move towards socialism: Can a genuine initiative come from the masses, and if so, can it flourish? The question has become no less pertinent in the years since Mao's death, with the playing down of movements like Huxian and the reversal of many of the ideas on which the paintings were based, and which are woven into their forms.

●

The devastating poverty of the peasantry in the old China has sometimes been compared with that of the Indian population today. The poor peasants – 70 per cent of the population – owned only 10 per cent of the cultivated land, and many more besides were landless labourers. Land reform had always been the sine qua non of any real change in China. Despite millenia of cultivation, Chinese agriculture had always been precarious and difficult and constantly wrecked by natural disasters. Accordingly, when the Communists came to power in 1949 they first carried out a survey of all the usable land in the country and then, at mass meetings, redistributed it equitably among the peasants. This first stage of individual ownership and work

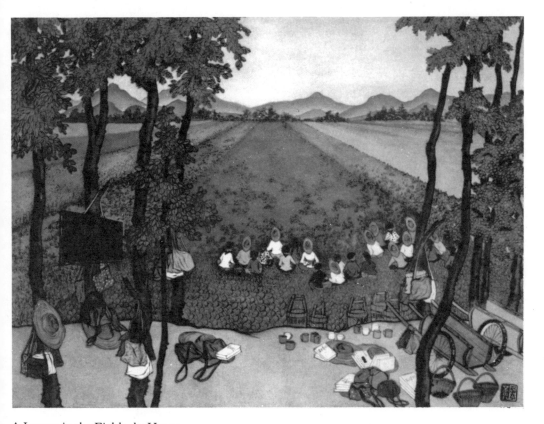

A Lesson in the Fields, *by Huang Yun-ting, a village schoolmaster. '...the first landscapes painted by people who are both the collective owners and "researcher-developers" of the land.'*

59

was followed by gradually more sophisticated forms of association: first the mutual aid teams which were similar to peasant organizations in traditional China; then the socialist cooperatives, which enabled technical improvements in farming to be made and large areas of waste land to be reclaimed; and finally in 1958 the communes. These are self-governing units into which industry (the worker), agriculture (the peasant), culture and education (the artist and student), and military affairs (the militia) were all integrated. It is this integrated life which is depicted in the Huxian paintings.

China, 1930s. In the early days of the Chinese revolution, many young artists, encouraged by the writer Lu Xun, turned the traditional popular medium of the woodcut, and the beauties of Chinese folk art, to recording the day-to-day events and the goals of the revolution.
Demanding Rent Reductions *by Ku Yuan.*

We might only have an outside view of these great changes if artists, the selectivity of the 'thinking eye', had not emerged as part of the developing process inside the communes themselves.

There was little precedent for this. The rural culture of China was on the point of being lost. In addition to their traditional exploitation by the feudal landlords, the farmers had also seen their supplementary income from handicrafts destroyed by the influx of mass-produced goods from the Western imperialist countries. When the Communist Eighth Route Army penetrated to remote areas during the 1930s they found the peasants using their spinning-wheels for firewood. Weaving and other handicrafts were revived in the liberated areas during the revolutionary war out of sheer necessity. And left-wing artists coming from the cities sought out the old rural folk artists and adapted their styles to carry revolutionary or educational messages. Mao himself said at one point that the new socialist culture would be the raising to a new level of the peasant culture. But the real impetus for a revival of the arts in the countryside were the political ideas which accompanied the economic and social changes of the 1950s, in particular the idea that the struggle against the old ruling class continued even after its economic power had been destroyed. There were other aspects of class far more complex and ingrained, bound up with the age-old legacy of a cultured intellectual minority and a majority who are simply physical, labouring beings. It was the attack on this 'division of labour' by millions of people in their specific situations – farms, factories, schools, hospitals, universities, theatres, etc. – up and down the country which culminated in the Cultural Revolution. And among its countless manifestations was the amateur painting movement in Huxian.

Develop Dynamiting in the Militia, *by Yen Han.*

60

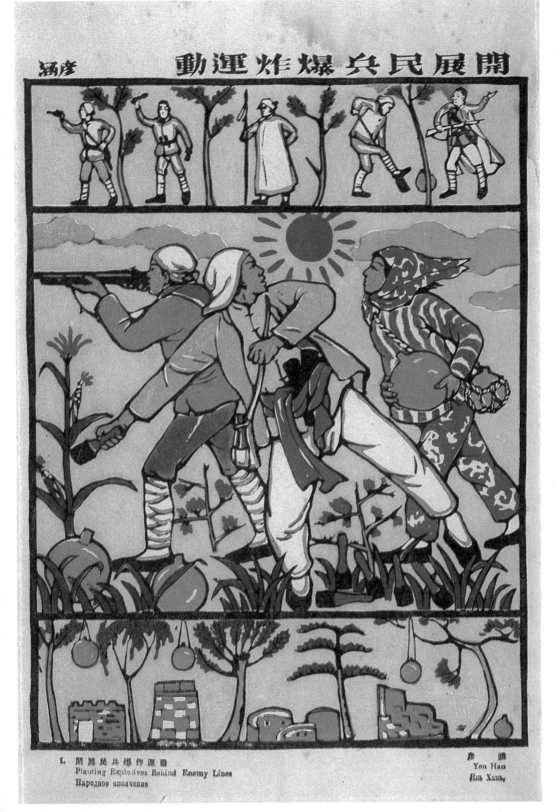

彦涵

開展民兵爆炸運動

開展民兵爆炸運動
Planting Explosives Behind Enemy Lines
Народное ополчение

彦涵
Yen Han
Ян Хань

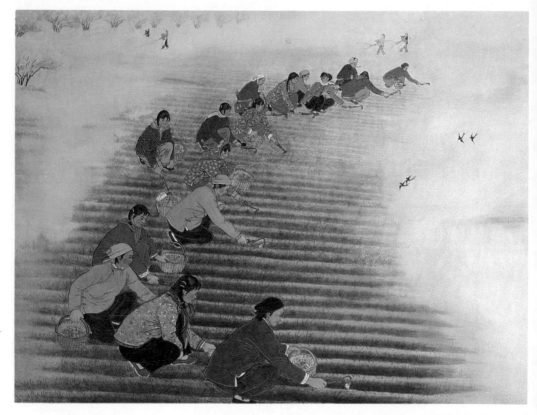

Spring Hoeing *by Li Feng-lan.*

Li Feng-lan, mother of four children, was one of the first to take up painting in Huxian.

Its beginnings were small. The local Party branch is said to have taken the initiative by setting up an art class on the worksite of a new reservoir in 1958, year of the Great Leap Forward, as a way of recording and celebrating the work in progress. At first they made their own paints from soot, red soil and lime. Professionals were invited in to give lessons. The difficulties of the early days and the very gradual development of a satisfactory means of expression have been described by Li Feng-lan, a woman with four children who was one of the first to take up painting. She had a love of visual things from childhood but no inherited visual culture; she had to learn from scratch how to portray what she saw, what she wanted. And there were other obstacles:

> It was no easy matter for a woman like me to take up creative art. I worked in the fields most of the year and had family duties at home. I could only paint in the little time I had for rest. Moreover, some conservative people looked askance at a village woman painting and made cold, sarcastic remarks.[2]

Gradually the movement spread. Village walls were decorated with murals, open-air exhibitions were held and small local art centres were built. The growth in density and precision of the paintings echoed the enrichment of the environment itself as the land was more efficiently cultivated, better houses built, clinics, libraries, sports grounds. And there were always new beginners. By 1976 there were said to be more than a thousand spare-time painters in Huxian. When their pictures were first shown nationally, in Beijing in 1973, their novelty was strikingly obvious. The mixture of naivety and sophistication of their image of collective work disconcerted some people and delighted others.

We, as foreigners, only know about Huxian painting because the Chinese authorities decided to take it as a model, to publicize it. We can know little or nothing about the art of workers and peasants which has not been highlighted. Like so many other visitors to China during the 1970s, I felt my initial euphoria and simple certainty soon replaced by a more modest and critical sense of how little I really knew about China, how hard it was to go beyond 'the outer gate'. Nevertheless I believe that much can be learnt from a study of the Huxian paintings. They are one among other means of insight that we have, one that is tied up not only with visual pleasure, but also with social and political questions of who makes art, and for whom.

63

From the purely aesthetic point of view, Huxian painting can hardly be compared with the great traditional art of China. The peasant pictures are basically illustrational. But within the mode of illustration it is the choices they make, the emphasis, the manner of painting and the mixture of fact and fantasy which makes them a radically new departure. Their innovations are closely interrelated with one another and, in a remarkable way, not only point to a future community of a kind which did not exist before, but also suggest a continuity with some very ancient popular desires. How is this expressed in visual terms?

Detail

The Huxian painters are women and men, old and young, experienced and beginners. They are farmers, teachers, 'barefoot doctors', peasant agronomists, pig-raisers, shepherds, herbalists, tractor drivers, vets, bookkeepers, mechanics, and some are, or were, young city people come to work in the countryside. Perhaps not all these occupations are held by different individuals, but in all the best paintings it is clear that the work is portrayed by someone who knows it intimately. In the *Piggery* painting, the sties are uniform, but of some 103 pigs and piglets depicted no two are quite the same! Nor are they solemn or merely useful. All kinds of pig behaviour are shown with obvious affection. The same is true of the pictures of flocks and herds. This may be the result not just of the painter's own observation but of suggestions by other peasants who have scrutinized the pictures during the several stages of production many of them pass through. Technology, which in the Chinese context is new and makes life easier, is often foregrounded and shown in intricate detail. But the work process is rarely shown in a superficial or summary way as a single, limited phenomenon. The *Crop-Spraying* picture, for example, gives equal emphasis to the home-made electric pump set-up and to the shoes of the crop-sprayers, their refreshment and their lantern for going home at night. What would be naive exaggeration for the professional outside observer becomes intelligent realism for those who are working the land.

64

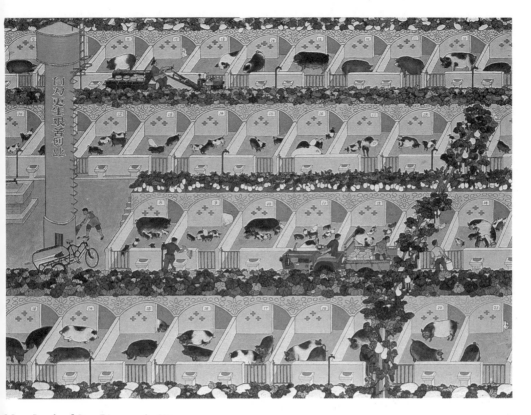

New Look of Our Piggery, *by Wang Yung-yi and Yang Chih-hsien. Painted to celebrate the completion of a commune piggery. The gourds growing along the tops of the sties are for pig-fodder. In the bottom row of sties, male pigs are kept; in the next row, females and young; in the next, young weaned pigs for eating; and in the top row, pigs to be used for breeding.*

Accumulation

As well as pin-pointed detail, the peasant painters love to repeat, to mass things, to accumulate. The crops, growing in neatly ordered rows, or lying in great mounds at harvest time, take up most of the space in many paintings. But where a detached observer might resort to visual shorthand, or a commercial illustrator to mechanical patterning, the Huxian painters, in the most striking cases, draw in every fruit, every leaf which makes up the mass. While the element of patterning suggests a uniformly high standard of produce, each plant has a vibrancy which makes you feel that attention and care went into producing it.

Cellular Composition

This 'inside view' can be felt not only from the details but often from the whole composition as well. Some painters have introduced a kind of multicellular composition which allows the emphasis to fall equally on many different activities, to show that one is not more important than another, that all are related. It can be applied to one particular work process, as it is in the *Piggery*, or used to give a kind of bird's-eye view of the whole production brigade, where you can pick out different crops being harvested, cotton being dried, pigs in pens, a boy shepherding ducks, lorries and hand-carts going to and fro, people reading a wall newspaper, and so on. Of course this synoptic form is a familiar technique of illustration, but the Huxian painters have enhanced it by compressing space and bending perspective to bring people, crops, land, machines – and even incompatibles like work and leisure – closer together.

66

'Primitive' as such visual devices may be compared with the brevities and subtleties of the classical landscape style, in today's context they are rich in implications. It is not really fanciful to see in them a 'husbandry of the picture-space' parallel to actual life, to connect the visual density of the pictures with innovations made by China's farmers in the same period, such as 'close-planting'. The enjoyable visual play in the *Piggery* between the uniformity of the sties and the individualism of the pigs seems to arise directly from a scientific attitude to farming. On the one hand the multicellular composition echoes visually the desire to build up a modern, integrated way of life in the countryside; and on the other, it seems to refer to a connection between painting and farming which may go all the way back to the most ancient times.

Crop-spraying, *by Yang Yang-tung. Enthusiastic detail is given to the ad hoc technology of the pump and other things of importance to those working the land: refreshment, the shoes of each worker, and a lantern for going home at night.*

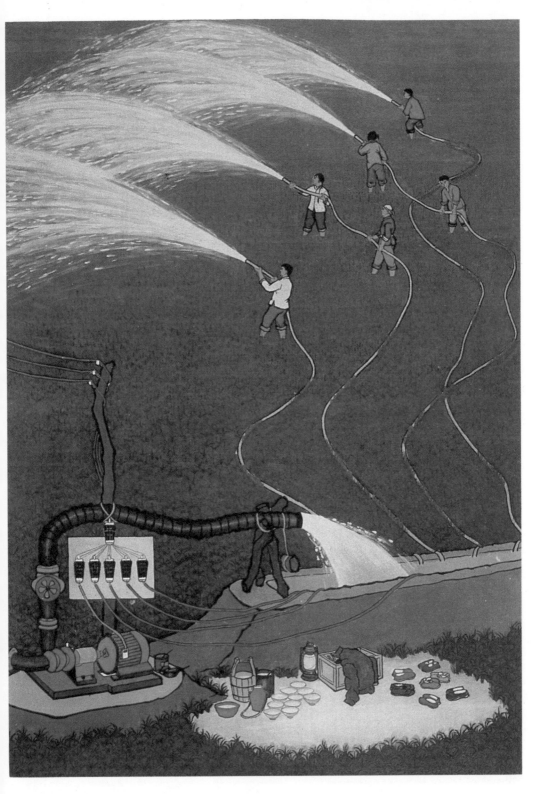

According to one ancient Chinese text, the *Shuo Wên*, the meaning of *hua*, to paint, 'consists in drawing boundaries and the raised paths around the fields'.[3] This suggests that painting (or one form of it) originated as a mapping activity and was closely connected with the invention of agriculture. The hunting peoples, to judge from the cave paintings, had an art without boundaries, where the cave walls echoed the vastness of the hunting grounds. But agriculture required a huge effort of containment, ordering and forethought. Animals had to be penned in, the cultivated land had to be weeded and marked off from the wilderness, the plants themselves became more compact, regular and healthy. It is hard to believe that this is not reflected directly in the phenomenon of decorative art, the patterns of flowers, fruits, animals or birds which, with infinite local variations, are common to peasant peoples all over the world. Playing on the contradiction between order, control, and fantastic profusion, decorative art sublimates the hard, monotonous farming work into a dream of abundance and plenty. The Huxian painters have not copied these forms but revived them in their picture of commune life.

68

Rubbing from a stone engraving of the Han dynasty (200BC-200AD).

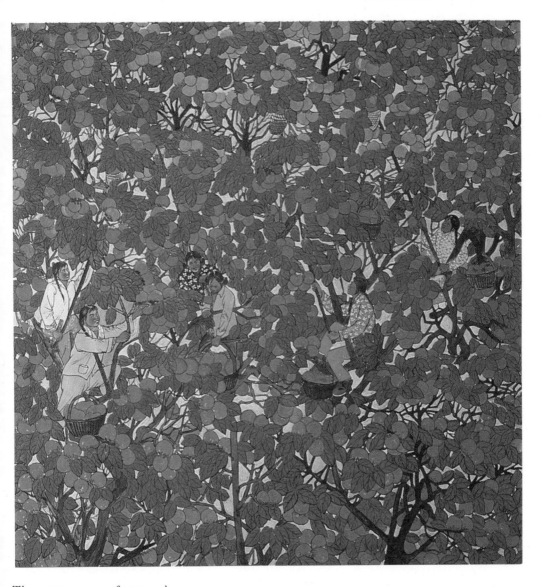

The sumptuousness of patterned
fabric, a dream of plenty, the
rationality of scientific farming.
Persimmons are Ripe at the Foot of
Mt Chungnan, *by Tu Chih-lien.*

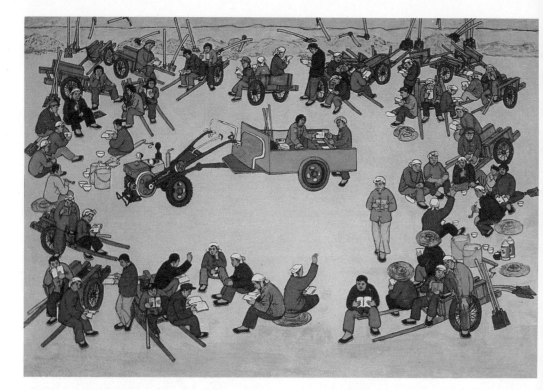

Library Comes to the Fields, *by Yang Shui-teh and Hsin Chiang-lung. A compendium of the gestures of reading. They are personal to each individual, but are shown within communal rather than privatized space.*

Gesture

In the *Library* painting, the device of accumulation is applied to 'body language' and gesture. It would have been simple to reproduce a few stock pictures of people reading, or to have synthesized them in one symbolic figure, but the beauty of this picture is the artist's observation of all the attitudes of people reading, conversing, thinking: people who may have only recently become literate. It is by the combination of true observation with the naive device of accumulation that this painting so freshly conveys a democratic spirit. Outside China, audiences have often remarked suspiciously that the people in Huxian painting are 'always smiling', and it is true that they are hardly ever individualized by features or psychology. But they are highly individualized by gesture. There is a huge repertoire of gesture: working, resting, studying, listening, greeting, conversing and so on. There is hardly ever an inert pose. Even in some technical manuals produced in China in the 1960s and 1970s you find that attention is given not just to objects and processes but to new social relations as well. In this kaleidoscope of gesture the Huxian people liberated themselves from every traditional image of the peasant and worker familiar from the history of art: as heroic, exhausted, clodhopping, comic, brawling, virtuous, merely physical, or threatening. But while individualizing them-selves as autonomous, thinking human beings, their gestures all tend towards integrating themselves in the group, the collective, which remains the real subject of the pictures. An intimacy, nuances of gesture which we might expect to focus on private feelings and 'personal' relationships, is given to the group in its practical life. At the grassroots there is celebration of *community*, but equally strongly a resistance to the image of *regimentation* often associated with socialist states.

72

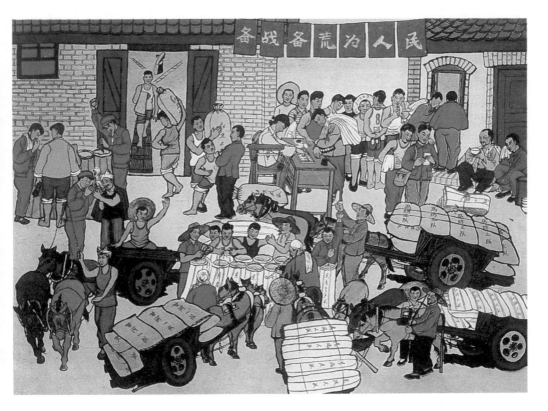

In the gestures and groupings of this picture, labour and leisure, production and conviviality, are not seen as complete opposites.
Grain for the State, *by Ko Cheng-min.*

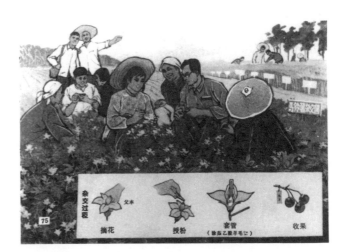

Page from an agricultural manual, China, 1970s.

Praise

It is often said that China has passed from a semi-feudal society, with strong kinship and clan structures and authority sanctioned by ancient tradition, directly to socialism, without a period of bourgeois individualism and liberalism such as we have known for several centuries in the West. Some precapitalist cultural forms, which express a strong sense of the identity and cohesion of a particular people or community, could pass over quite easily to express the ideal of communism. The unflagging optimism of the Huxian paintings, which offends against our notion of reality even while we are carried away by its energy, belongs in one sense to a recognized genre common to many precapitalist societies: the eulogy, or praise-poem. Hyperbole, decorative flourishes, striking figures of speech, are often linked with a precise itemization of all the aspects of the thing to be praised, just as the Huxian painters mix commonplace detail with the dream of a prosperous and good society. Facts are never cold, ardent feeling is not detached from material reality. Modern peasant paintings are considered to belong to the popular tradition of New Year Paintings (good-luck images); another, particularly beautiful example of a precapitalist form carried over into 'socialism', is Mongolian oral poetry, some of which has been translated by C.R. Bawden of Cambridge University. One such poem, a benediction for the yurt, the nomadic dwelling, praises with striking metaphors all its materials and every object inside it, and ends thus:

> Let us offer up
> With loud voice
> A prayer for lasting good.
> May this family
> Gather all its beasts together outside,
> Fill its tents with scholars,
> Have a full set of carpets,
> And plentiful food and fruit set out,
> Be merry day and night,
> Give food to all
> Who pass by upwards,
> And drink to all
> Who pass by downwards,
> Be too rich in foals and colts to know them,
> Be too rich in children to know them,

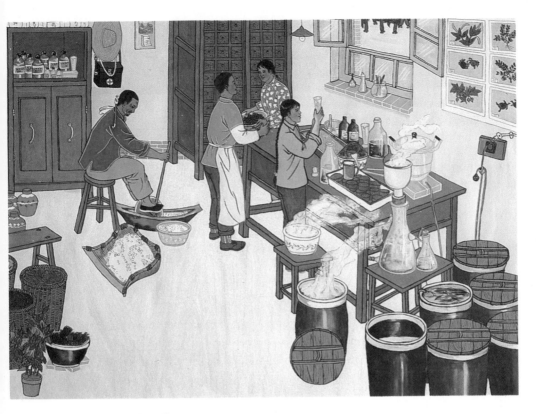

Our Own Pharmacy, *by Liu Shuan-chin. China suffered the typical Third World pattern of an almost complete lack of medical facilities in the rural areas. Here novelty, detail and eulogy go together. Baskets of freshly collected herbs stand on the left. The bottles in the cupboard probably contain Western medicines, the big cabinet traditional Chinese remedies. On the wall between them is a 'barefoot doctor's' bag and sunhat. Wall-charts on the right show several plants, as well as crabs and turtles, used in traditional prescriptions.*

75

Make their koumiss-bag of elephant-skin,
Make their koumiss-paddle of sandalwod,
Make their ornaments of magnolia flowers,
Peg out a tethering-line sixty fathoms long,
With foals tethered to it like minnows,
May they swarm with one hundred thousand people,
May they jostle with ten thousand people,
May the Commonwealth
Be firm like an iron surround,
May we humans
Flourish like the flowers of spring.[4]

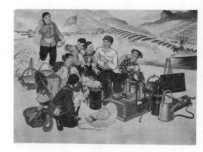

Learning about the Hero Lei Feng,
by Chao Kun-han,

'You' – 'We'

Up to now I have described only one kind of painting
which Huxian artists were producing during the 1960s
and 1970s, the kind that the artists themselves call
'masses paintings'. There are other kinds too; in fact
the same individual will quite often produce pictures
of several completely different types. Yet it seems
unquestionable that the 'masses paintings' are the most
original, both in form and content. Even though the
subject may be similar, and the attitudes of the artist
presumably consistent, certain compositional forms
seem more capable of expressing new and revolution-
ary relationships than others. For example, *Learning
About the Hero Lei Feng* by Chao Kun-han and
Learning Through Practice by Shan Chun-jung have a
similar theme of one teaching and the others listening
(the 'hero' in the first picture was a young soldier who
'served the people' and died young in 1964; the second
picture shows middle-school students on an outing to
learn about farming). The first picture adopts the old
hierarchical composition inherited from Soviet social-
ist realism where the spotlight falls on a single
individual and the others are in supporting roles.
Gestures are stylized and inherited from cultural
tradition (in this case probably Beijing Opera). Nature
forms a mere backdrop for the stage of human action.
In the second painting teacher and listeners appear on
the same level as one another and also as the trees
which are the subject and meaning of the teaching.
The gestures of the students are as varied and fondly
observed as the readers in the *Library* painting. And
here nature is interwoven with people, both in its
productive form – showing three stages of cultivation
– and as beauty and pleasure, hinted at by the flower
the girl standing at the back is holding and the
butterfly hovering near her.

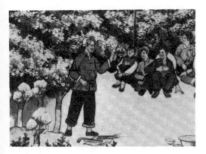

Learning Through Practice *(detail)*,
by Shan Chun- jung.
Differing styles, differing philosophies,
applied to similar subjects.

Both paintings have an element of didacticism, in their subject and their style. Whereas the first is paternal and seems to say 'You', the second is egalitarian and says 'We'. The memory-traces of different historical styles confirms this: the hierarchic grouping could be traced from socialist realism, through 19th-century academic painting, all the way back to the altar-pieces of Renaissance and medieval Europe which were themselves a powerful component of the feudal lords, and the church's authority over an uneducated population. The second painting is closer to peasant and folk traditions.

But in the end it is not one compositional device or another which determines the vitality of the paintings. Both can be reduced to lifeless formulas, either of a supposedly 'elevated' or of a supposedly vernacular and charming kind. The best pictures are either those whose mass of factual detail gives insight into Chinese socialism or some inspired visual hybrid in which the artist has come close to the real experience of the peasants as something both practical and visionary. When I visited Huxian in 1976, the socialist realist-style paintings were given pride of place in the specially built gallery of peasant painting in the county town, and I felt that officialdom had intervened with literal notions of 'political content' and academic ideas of 'high art'. But six years later it was the folk-art element of decorative patterning which was being singled out.[5] In the process of being groomed as a schematic model to copy, both genres seemed to lose their light touch and qualities of humanity and realism.

All artists are subject to pressures from outside. In China there is no art market and financial speculation in works of art, and therefore no pressure on artists to make saleable commodities. But mediators of other kinds exist in China and play no less influential a role. The different influences

77

Peasants discussing paintings,
Huxian, 1966.

acting on the peasant painters come from different positions within Chinese society, with subtly differing notions both of 'the truth', and of the desired efficacy of painted images. The artists are spare-time painters whose main activity is the work in the commune and whose paintings are directly concerned with commune life. Undoubtedly much of the characteristic density and vivid detail is due to suggestions made to the painter by other peasants, and pictures often go through several 'drafts'. In this context the notion of efficacy is bound up with the needs of community: painters are both documenters and inspirers. Most images are some kind of mixture of how things are and how they could be. But as well as being ordinary brigade members the painters are inevitably linked with the world of art. Their pictures have been shown all over China and the world. The relations between amateur and professional artists have different implications in socialist China from those in the West, where the two groups probably never come in contact. In China 'amateur' does not imply a private hobby but an active assault on the traditional monopoly of culture held by the educated and leisured class. Visiting China in the mid-1970s, it was impossible not to feel electrified by the sheer energy and confidence of amateur painters, musicians, dancers, acrobats and others, which seemed like a powerful social force of a new kind. At its best, their relationship with professionals has been one of mutual enlightenment: the classically trained painters impressed by the peasant artists 'taking liberties with form which we would not dare to do',[6] and the amateurs learning refinements of brushwork and drawing.

The relationship between the painters, as the original producers, and the cultural cadres, as the middle-people, 'managers' or administrators, is much harder to determine. But it is as vitally important in this particular field as it is in China as a whole or indeed in any country where a bureaucracy is in a position of facilitating or obstructing popular initiatives. If they cannot be discerned directly, I believe these tensions can be read from the qualities of the pictures themselves. In almost all of the most satisfying Huxian paintings you feel a passionate and witty observation of reality, and a clear concept of a better ordering of society, struggling against limitations of technique. This is the source of their originality as a 'socialist new thing', the originality of the historical moment rather than a cultivated naivety of style. As the paintings edge away from this authenticity they edge towards kitsch – the grandiloquent kitsch of socialist realism or the whimsical kitsch of schematized folk art. An

A painting that says 'We'. Even from behind, nuances of posture prevent an image of regimentation. Recalling the Revolutionary Wars, *by Tu Chih-lien.*

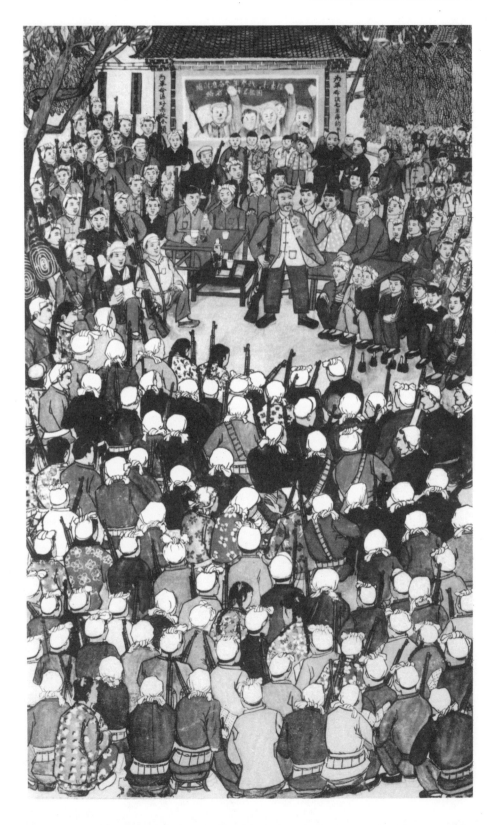

apt description of kitsch as 'vicarious experience and faked sensation'[7] fits such paintings and suggests the interference of people who cannot really feel identified with the sources of this art.

The traditional class structure of China, the centuries-old contempt of the mandarin class for manual labour, has proved extraordinarily difficult to eradicate, and even today sometimes has a virulence which would shock our own ruling class. But as well as open distaste it can just as easily take the inverted form of 'workerism', worship of manual labour which is inauthentic and schematic, and equally conservative because it validates labour as such rather than treating it as a means to certain desired ends. If treated from this perspective the legacy of folk art also becomes patronizing and constraining: the art of simple people, village people, rather than a popular source to be transformed with modern energies and world consciousness.

It is difficult for an outsider to describe the evolution of Huxian painting, or bring the discussion up to date, because of the difficulty of obtaining continuous information from China. We *can* see from outside that the vitality of Huxian painting is inseparable from the profound social questions which were raised on a mass scale in China under Mao's

Return to privatization? Golden Harvest Days, *by Yang Guang-lin, a 1984 peasant painting from Shaanxi province.*

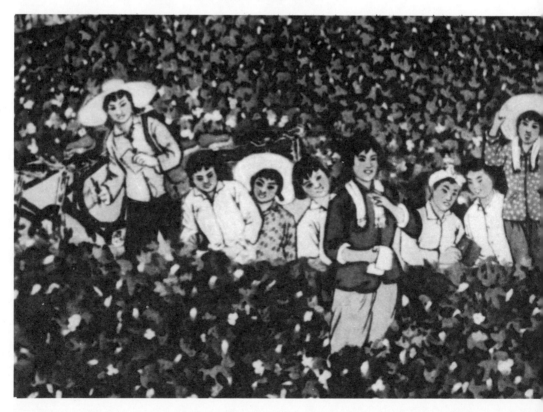

leadership. From the selectivity of their realism, their humour – and also a quality of love – we feel an authenticity which cannot be handed down from above. The Huxian paintings veil the individual life. They say nothing about the psychic dilemmas and tensions of such social changes which of course take place at the level of the individual consciousness. They describe an epic period of public works, mass mobilization and tight discipline – and it is into this that they have given us such humane insight. It is hard to know how far Huxian itself has reflected the changes of policy in China since Mao's death, which, among other things, have encouraged the growth of commercial and business enterprises by individuals and groups throughout the countryside. A recent peasant painting from another province, Shaanxi, shows a startling change of viewpoint. The familiar elements are there: house, tractor, tools, sacks of corn, animals. But they seem to emanate from and converge on the individual as if they were his personal property. He lies in the centre relaxing with his transistor. Just official Chinese 'cover art' perhaps – the image itself is slick and kitschy – but such transparent reversion towards privatization makes all the more daring and original the Huxian peasants' collective self-portrayal.

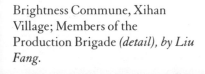

Brightness Commune, Xihan Village; Members of the Production Brigade (detail), by Liu Fang.

81

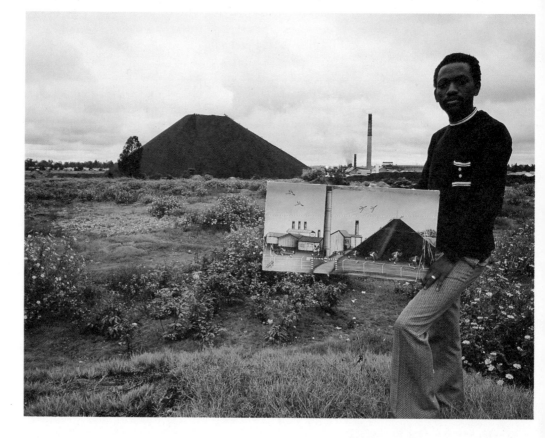

Tshibumba Kanda-Matulu, Zairean popular painter, in front of the copper smelter at Kolwesi. His painting shows the fighting which took place here in 1960. Katanga (now Shaba) province, where most of Zaire's mineral resources are concentrated, seceded shortly after independence from Belgian colonial rule, and UN troops, with the approval of the central government, were sent in to re-unify the country. It was a harrowing time for the population. Photo: Etienne Bol.

CHAPTER 3

NO CONDITION IS PERMANENT

The very term 'African art' is intimately connected with the history of Europe's colonial relationship with Africa. Up until recently, reports on African art were overwhelmingly 'for the West'. They emphasized what was of interest to Western audiences and remained silent about, or were ignorant of, anything else. The permutations of this basic inequality have been endless. A Renaissance interest in African musical instruments and dancing gave way, in the early 20th century, to a liking for the masks and statuettes, which could most easily be exported and collected as 'art objects'. This in turn gave way to a more recent interest, stimulated by anthropology and ethnology, in the ensemble of mask, costume, dance and ritual as a total art form. In the complex contemporary world different interest groups vie to create an image of African art: Western museums which are still largely preoccupied with 'traditional' art, emigré artists from Europe who settled and created 'schools' of artists in some African countries, collectors seeking the ethnic and exotic, and the tourist industry catering to a suburban notion of the 'primitive'.

Of course these attitudes cannot all be equated, and there have always been sensitive and honest researchers. But what, in different ways, all these groups seek is an 'African essence', outside time and history; or to put it more precisely, based on a schizophrenic view of time and history, which assigns Africa eternally to the 'pre-modern', while representing it and interpreting it according to the latest Western tastes and notions. As Amilcar Cabral so aptly put it: 'The colonialists have a habit of telling us that when they arrived in Africa they put us into history. You are well aware that it's the contrary – when they arrived they took us out of our own history...'[1]

Therefore an acute awareness of conditions and changes of social reality, and an African view of history, are necessarily part of the whole process of decolonization. This is already quite well-known in the work of an intelligentsia of African writers, film-makers, musicians, poets. But recently it has been augmented by reports of the vigorous new popular cultures growing up in the towns and cities since independence: African art for an African public.

One of the most detailed and perceptive studies of a popular painting movement in Africa has been made by two anthropologists, Ilona Szombati-Fabian and Johannes Fabian, in Shaba, the copper-producing region of Zaire. Their studies are informed by a sensitive awareness of their own position as mediators. An opposition to the Eurocentric constructs concerning African art enabled them not only to *see* a kind of artistic practice which was invisible to foreigners – both tourists and long-term residents of Zaire – but also to investigate and discover the extent and sophistication of its role in the life of the people.

No discrete body of work was laid out conveniently for study. By searching out pictures – whether they were attracted or repelled by them – by talking with painters and public and learning to identify and interpret different genres in an incredibly prolific production, they became aware of a new art form which reflected in complex ways the experience of the masses in urban, post-independent Africa: not only reflected it, they realized, but was actually generating a group's consciousness of its history through visual images. In this sense, the pictures were not objects of contemplation in the Western sense but 'reminders', the starting point of stories of shared experiences. For the description of Shaba painting which follows, I am greatly indebted to their researches.[2]

84

Portable, representational painting was unknown in the traditional arts of central Africa. Its appearance in modern Zaire is inseparable from historical change and new conditions: Zaire's achievement of independence from Belgian colonial rule in 1960, processes of industrialization and urbanization, and the availability of new materials (in the case of painting, of oils, acrylics and canvas – which, however, are the most basic: house paints and pieces cut from flour sacks). Though self-taught, most painters are professional and sell their work directly to the customer. Profit margins are small: a painter must sell at least one painting a day to support himself and his family.

The life, like the landscape of Shaba in south-east Zaire, is dominated by the copper industry. The working population live either in settlements provided and serviced

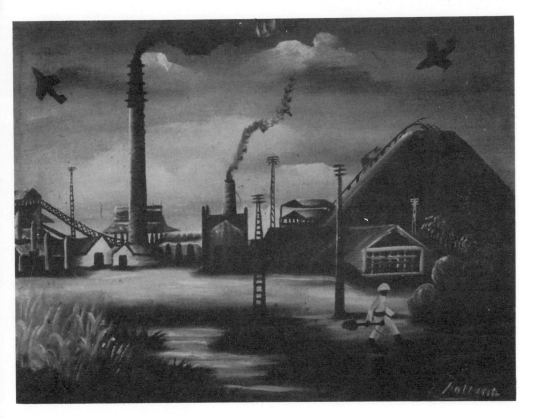

Things Present: The Smelter *by*
Kalema.

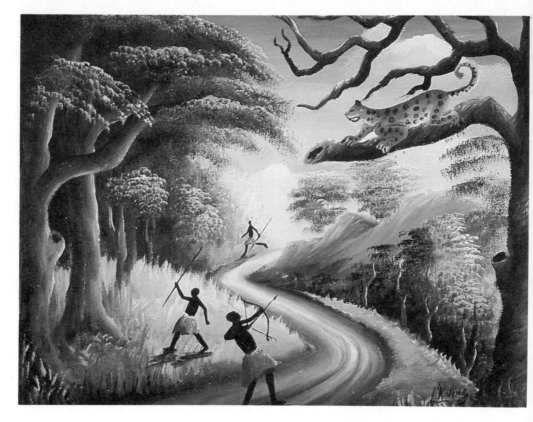

Things Ancestral: The Hunt *by Kalema.*

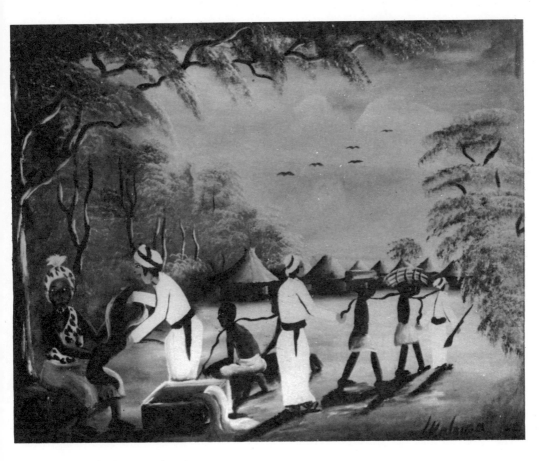

Things Past: Arab Slave-Traders *by
Kalema. A collective memory of
painful events. In the late 19th
century Arabs were taking slaves
throughout East Africa, sometimes
with the complicity of local chiefs.*

by the mining company or in unserviced squatter camps surrounding the commercial and residential (and formerly European) centre of Lubumbashi. Though many originally came as immigrants from other parts of the country, the population has reached its fourth generation and shares a common history marked by the traumatic upheavals which have shaken this part of the country: revolts and strikes during the Second World War, the fighting leading up to independence and erupting again with the Katanga secession of 1960-63, Mobutu's rise to power in 1965, and the armed uprising led by the Congolese National Liberation Front against the Mobutu regime in 1977.

Life is hard and precarious in the city, but probably less so than in the destitute countryside. Many Shaba people no longer see themselves as emigrés from the villages. As far as they can, they aspire to an urban lifestyle. In a dramatic break with village traditions of receiving guests, drinking and eating outdoors, Shaba city-dwellers began setting aside an inside space as a 'salon', the centre of social life and family pride. It is for this room that the popular paintings are bought and hung.

One of the most important discoveries for Szombati and Fabian was learning of the existence of a system of *genres* into which individual paintings fitted. Only then could they see more clearly the social nature of the paintings as a process of communication. By collecting and comparing pictures and learning the terms painters and buyers used to describe them, they could go deeper than superficial descriptions such as 'naive art', 'portrait', 'landscape', 'historical painting', to find connections with an underlying schema which involved both a shared interpretation of history and a shared response to present-day predicaments.

The genres are marked by different conceptions (representations) of time and events. In a genre which Szombati and Fabian called Things Ancestral are pictures referring not to specific events but to an idyllic memory of life in the village, with its hunting and fishing, powerful animals, venerated chief and elders. Things Past refer to specific and usually painful events, going back as far as Arab slave-trading, which was common in east Africa in the 19th century, through the period of Belgian colonialism, to the violent upheavals of Shaba's recent past. These events are seen very much from the point of view of the ordinary people. Things Present include pictures of the copper smelter at Kolwesi, urban scenes, portraits and shop signs. In a genre of its own is the *Mamba Muntu*, a local version of the mythical Mamy Water, or mermaid, which is widespread and has very significant meaning in modern Africa.

Things Past: Simon *by Tshibumba Kanda-Matulu. Simon Kimbangu was a religious leader in the early 20th-century Congo. He foretold the coming of a messiah who would give Africans back their rights and their dignity. The church he founded quickly gained a huge popularity. But he was attacked both by the Catholic missions and by the colonial army. He was brought to trial by the colonial authorities on 3 October 1921 and sentenced to life imprisonment. He died six years later, without seeing his family again.*

Things Past: Attack on a Train *by Tshibumba. In 1960 Moise Tshombe led an attempt to detach the mineral-rich province of Katanga from Zaire. Trains carrying his troops, which included many mercenaries, were repeatedly attacked by militants of the local Balubakat party, strong supporters of the integrity of Zaire and of the central government led by Patrice Lumumba, independent Zaire's first Prime Minister.*

88

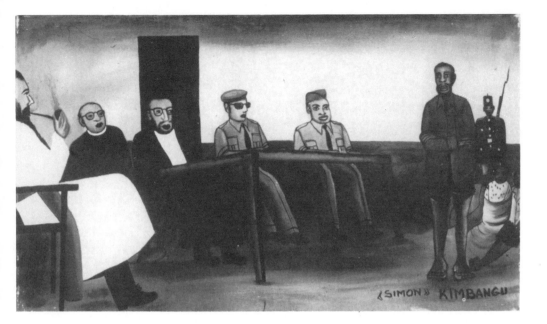

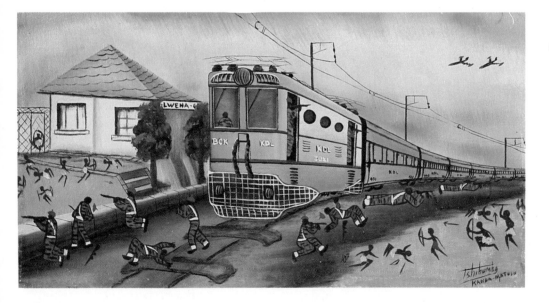

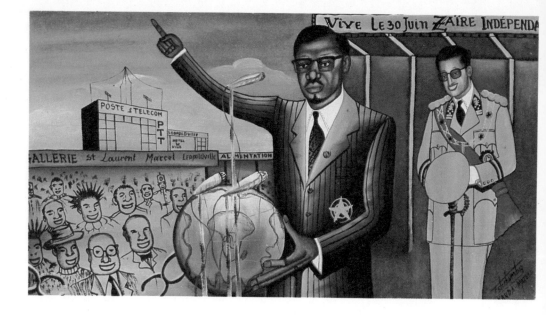

Tshibumba working at home on the painting above. He holds a housepainter's brush in his hand. Photo: Etienne Bol.

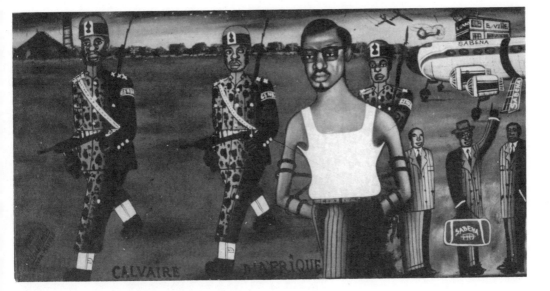

Tshibumba Kanda-Matulu has painted a history of Zaire in more than a hundred paintings. The great hopes and tragic developments of the period of independence are movingly portrayed in his life of Patrice Lumumba. Top left: *As King Baudouin of Belgium stands humbly in the background, Lumumba points to the new world with Africa at its centre and everything people hoped would come with independence: wealth, technology, European clothes and shops – modernity.* Above: *Painted in grisaille, Lumumba is brought bound to Elizabethville (now Lubumbashi) airport shortly before his murder in January 1961. He is 'welcomed' by three Katangese ministers (in pinstripe suits). Their gesture towards the Sabena plane appears to link them to Belgian and international capital, and the machinations which brought about the death of Lumumba himself and his dream of socialism. (See cover for another version of this subject.) In all the paintings Lumumba's head is painted with great realism and dignity.*

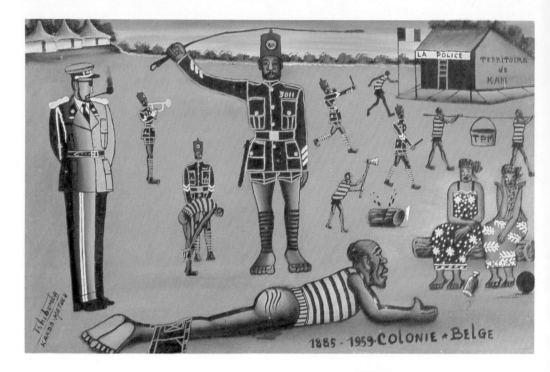

Things Past: Colonie Belge. *A memory-synthesis of Belgian colonialism which becomes an image of all colonialism and its impact on the colonized. This is one of the most popular genres of Shaba painting, and the essential elements are always the same. This version by Tshibumba.*

The effectiveness of the Shaba painters in selecting and powerfully summing up an important experience of the people can be clearly understood by taking a closer look at one particular genre in the category of Things Past: the *colonie belge*. Szombati and Fabian collected and compared several versions by different painters, and here I would like to quote directly from their interpretation. The scene is almost invariably a yard or open plaza in front of a colonial prison. While one prisoner is being flogged by an African policeman, the white administrator looks on. Further prisoners and guards, and other significant figures, are often included. How do elements of composition and gesture articulate the message?

> Some artists concentrate on activities in the prison yard; others, by the way they place the horizon, suggest the vastness of these administrative and punitive establishments. What surprises is the absence of walls or other containing structures. The scene is an open plaza, and, in more than half the paintings, a road running through the centre and along the periphery suggests a kind of boundless, peripatetic presence of colonial rule ... The prison is not a place where some people are locked up; it invades the lives of people.[3]

> The other element that matches the road/plaza in its central position is the prisoner being beaten, often together with the policeman who does the beating ... Together with the fact that he is mostly depicted as an onlooker (his strongest gesture is an outstretched arm) [his] off-centre position makes the colonial official seem strangely remote from the beating which is the dramatic core in almost all the paintings. To be sure, the White is associated with powerful symbols evoking colonial times and may not need a central position for the same reasons as the Belgian flag. On the other hand, none of the painters bestow on him the kind of meanness and active cruelty that makes the African policeman a target of rejection. One wonders whether this is not meant to evoke the remoteness and abstract nature of colonial power so often discussed in colonial times.[4]

Other details, too, required for their understanding a knowledge of the local culture:

> We were also intrigued by the frequency with which prisoners are depicted as being bald or balding. An obvious explanation would be that prisoners

93

were shaved as in many other places in the world. But this conflicts with the fact that painters in our sample use baldness selectively. Natural baldness is relatively rare and it would thus be an even stronger sign of maturity or old age than in our culture. On the other hand, to shave one's head (among women as well as men) is a custom associated with mourning. We may assume, then, that baldness, as a cultural symbol, accentuates the degree of humiliation and evokes a diffuse sense of sadness.[6]

The *colonie belge* is clearly much more than a depiction of a specific event. It is a kind of icon of colonial domination which has been constructed out of collective memory. It must therefore, as Szombati and Fabian point out, also be an active element of present consciousness:

> Paintings of *colonie belge* express the omnipresence of powerful, organized, and bureaucratic oppression of the little man as he feels it now, in a system whose decolonization remains imperfect and which constantly uses the former oppressor as a negative counterimage. *Colonie belge* is an eminently political genre ... The colony (symbolized by the African policeman as much as by the White) is present now: the little man is still being kicked around, while the society to which he feels close (symbolized by his family and the village) remains as impotent as before.[7]

Colonie Belge *by Kalema.*

But the Shaba painters do not only express this predicament of the little man as a kind of narrative of temporal events and social types. In another genre they have projected it on the psychic plane in the charismatic form of a mythical being: *Mamba Muntu*, the mermaid. This is by far the most popular genre among working-class buyers of Shaba paintings. It is also the one which has appeared most frequently in Western museum 'surveys of contemporary African art', as a strange and surreal image offered without any explanation.

Colonie Belge *by B. Ilunga.*

Mamba Muntu, according to the authors, is not so much a person as a generic being which is said to live in many lakes and rivers of the country. The one who is lucky enough to obtain a lock of her hair, or any object associated with her, and promises absolute fidelity to her, may expect to suddenly become very rich. In Shaba, to raise oneself out of poverty is virtually impossible. The gap between the working masses and the few Africans in managerial or governmental positions is, and always has been, enormous. But it is an ever present dream. Whatever else the story may

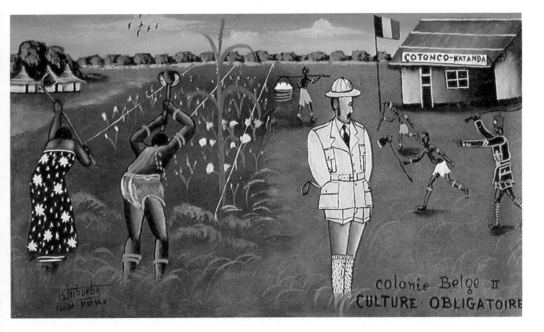

Colonie Belge – forced labour *by Tshibumba.*

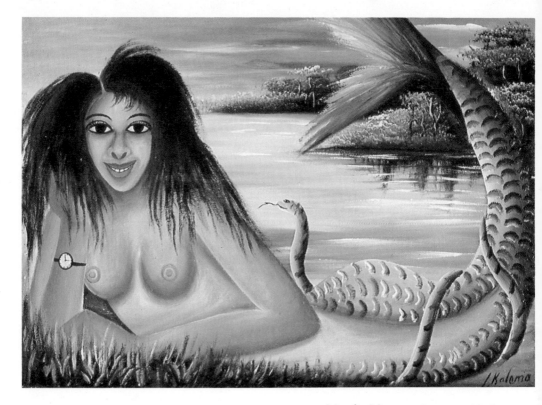

Mamba Muntu – *the mermaid, the most popular subject of all with working-class buyers of Shaba painting, and a kind of symbolic 'key' to the other genres. By Kalema.*

96

imply, visually *Mamba Muntu*, with her 'exotic', non-African features, her opulent arms which often encircle a diminutive man while her eyes look straight at the spectator, is personified as a dangerous and unfathomable being. In the new city, unlike in the village, the sources of wealth and ease seem capricious and inexplicable. *Mamba Muntu* can be seen as 'a powerful metaphor for the situation of the urban masses ... a most eloquent "reminder" of the continued control exercized by anonymous foreign capital'.[8]

●

In Shaba, popular painting is only one, and not the most noticeable, form of a thriving new urban culture. Music, as always in Africa, is its main expression. The popular painters often produce commercial work like shop signs, bar paintings and portraits alongside the pictures described above; many of them are musicians as well. Broadening out from Shaba, and Zaire, to Africa as a whole, the pattern is remarkably similar. As far as popular visual art is concerned there is a striking stylistic consistency both across the continent and across the various needs and demands for which painters paint. They have formed a hybrid, truly vernacular language. It appears to owe something both to modern Western commercial art and to the physical presence and dignity of traditional African portraiture and figure sculpture, yet it is neither the tail end of an indigenous tradition nor a submission to the Western onslaught. Africa today shows a popular culture in the process of formation, a vibrant and creative phenomenon which seems to flow into every department of life: the sacred, the political, the commercial, the domestic, even children's play. And in each case, despite differences of purpose, it produces signs equally eloquent and metaphor-ical of a people's encounter with modernity.

Proverbs and homilies are being newly invented and, in countries like Nigeria and Ghana, are painted on the sides of lorries or 'Mammy-trucks' (the title of this chapter is one of these). Paintings of hairstyles in barber shops have ostensibly a utilitarian purpose, but since they are not slick corporate products imposed from above they cannot help exuding human warmth and conveying all the vitality of new social types. In religious shrines, hieratic representa-tions of the old gods can often be found side by side with detailed imitations of modern industrial objects. Children's toys of wire and tin are as closely observant of the city as their clay toys used to be of village life. In fact, in ways which will be discussed in more detail below, it seems

97

Mamba Muntu *by Kalema.*

98

Watchmender's sign, Ivory Coast.
Photo: Jacques Clauzel.

justified to consider African children as protagonists of popular culture. Instead of being the consumers of a special child's world created by adults, as Western children increasingly are, African children's toys and games in certain senses give a lead to the world of adults.

Africa is constantly described as a society in transition. The continent is always taken as the perfect example of the conflict between a traditional communal life – the village, the network of kinship, a participatory culture based on collective dance and music, a non-linear view of time by which history, the dead, live on by the side of the living – and the modern industrial life based on money, private ownership, the nuclear family, bureaucratic control and the dream of personal success. The conflict is usually described in a polarized, monolithic way. But perhaps the outstanding characteristic of the African situation is that it never becomes a matter of 'either or', a loaded choice; change, the conflict between traditional and modern, is *lived* in all its complexity and fragmentation.

The indigenous cultures defined and defended themselves against the onslaught of colonialism. Despite their almost complete contempt for Africans, the European missionaries, administrators and soldiers could not destroy their culture which in essence was not identified with architectural monuments, libraries, complex divisions of labour, or even the masks of dance, but with community relations and ritualized everyday activities. African culture survived at the village level. As Amilcar Cabral wrote:

> Repressed, persecuted, humiliated, betrayed by certain social groups who have compromised with the foreign power, culture took refuge in the villages, in the forests, and in the spirit of the victims of domination. Culture survives all these challenges and through the struggle for liberation blossoms forth again.[9]

99

At the same time the continent has always been a patchwork of many peoples, many languages – many travellers. There has traditionally been a cosmopolitan as well as a village consciousness. The growth of industry and urban settlements both confirmed and contradicted this inheritance. In the vernacular images the romance and novelty of city life is felt: bars, dance halls, fashions, seductions, money, all that is summed up in the culture of Highlife – the antithesis of the austere, narrow, regulated village life. And on the model of the great traditional African markets, the cities are open to all influences, all commodities. But the excitement vies with the feeling of alienation, of loss and powerlessness, and the desire to

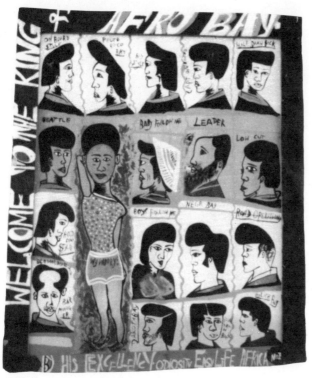

New style, new people. Barber-shop sign by His Excellency Odiosity, West Africa.

return to the home village. For these are not the stable, autonomous cities of an independent Africa. They are the creations of the neocolonial economic system, with its constant turmoil of opportunism, speculation, expediency, corruption. The highly visible and ostentatious power of a local ruling elite is combined with the remote, intangible power of foreign capital in an incongruous alliance which intimately affects everyone's lives. Whereas under colonialism Western culture was imposed by force or by education – by confrontations essentially between people – under neocolonialism it is felt as a flood of consumer goods and products of the entertainment industries.

The response of the intelligentsia to these experiences has been in many ways different from that of the masses. With more leisure perhaps to ponder their implications, some art-school educated artists in many African countries have become acutely aware of the need to resist the Western onslaught. But precisely what and how to resist? The web is very complex. In a series of articles aptly titled 'The Dilemma of the Contemporary African Artist', which were published a few years ago in *Transition*, the Ghanaian painter H. Ato Delaquis described some of these

100

Signs of modernity. Family *by an
unknown Nigerian popular painter.*

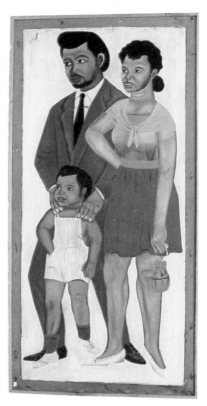

Not For Friend II *by Y.K. Special,
Nigeria. Coll. Gunther Peus,
Hamburg.*

101

contradictions. He felt himself to be, along with half of Ghana's population, an urban African:

> Here is a list of what Ghana culture is to me now: 'Star' Beer, 'Club Mini', 'Ah Star' posters; Football matches on Sundays; Garth and Kong strip-cartoons; Dark goggles and beer bars; Coups d'etats; Toyota taxis and Benz Buses; The Microphone and Amplification equipments; Akpeteshie gin, Palm Wine, Tiger Pito; The Kaba and Cover-shoulders, also Hot-pants, Skin-tights and Bell-bottoms and Platform-shoes; Sunlight soap; Lux and Omo; Ladies on TV teaching how to speak English correctly, or how to prepare small-chops; Dances from 9 pm T.D.B. (Till Day Break); the Soul and Pop groups, and the Big Bands; The Record-Player and Foam Cushions; James Brown and P.P. Dynamite; Spiritualist Churches; Freemasonry and Lodges; Beauty Parlours; James Bond films and Spaghetti Westerns; Funerals; Draughts at the roadside (not *Oware*); Vulcanisers and roadside fitters; Sayings on Mammy-trucks and Buses, etc, etc.[10]

For him to recreate traditional art forms would be absurd. He was very aware of the two-sided and contradictory pressures of Western domination: on the one hand to reject African values in favour of modernity, and on the other to produce the neo-traditional, ethnic imagery demanded by Westerners (until recently the only buyers of the work of art-school trained African artists). He could set down his ideal: 'To express the environment, the whole physical and spiritual concept of my society in the flux of change, using both my knowledge of Western and traditional concepts'[11] and to revive the tradition of African art as 'LIFE in which everybody participated for its blessings'.[12] Yet he would look in vain for support for such a project.

But in a sense this is exactly what the popular artists have been able to do, acting out of material necessity. Where the intelligentsia experiences change as dilemma, the popular painters, musicians and writers take hold of foreign influences and materials with both hands and transform them with incredible inventiveness. They show the exaltations and sufferings of the urban life with completely frank ingenuousness. Their sheer vitality and openness to surprise liberates them from the cold controlling cadences of the 'language of the oppressors':

The world is hard ... Bar painting at Bo, Sierra Leone. Photo: Ben Oelmann.

Cover of a popular novel published at Onitsha Market, Nigeria.

BOYS AND GIRLS
OF
NOWADAYS

Deity is my pasture, I shall not be indigent.
He maketh me to recompense the verdent lawn
He leadeth me beside the rippled liquidities,
And he conducteth me in the avenues of rectitude
For the celebrity of his appelation.
Undoubtedly, though I shall not be perturbed
By any catastrophe for thou art present.
Thou preparest a refection before me in the presence
 of my enemies
And quench my ungroshonological revevelence
My commiseration shall continue all the lutony of
 my vitality
And I shall eternalise my habitation in the metropoles
 of nature.
(Paraphrase of the 23rd Psalm from *Mr Rabbit is Dead*
by Ogali Ogali, a popular novelist of Onitsha in
Nigeria)[13]

A fascinating and revealing study could be made of the
intrusion into African art forms of the images of modern
objects, of consumer goods. For their presence is not only
visually striking; it also seems to mark a particular
historical stage, illuminating the forces that are at work.
These objects are treated with a consistent realism, whether
they appear in the sacred ambience of a shrine or the
commercial environment of the street, shops and bars.

In Mbari religious houses, which the Owerri Ibo of
Nigeria periodically constructed until recent times, mud
tableaux depicting the very latest in modernity – cars,
radios, bottled beer, schoolchildren in uniform, a fully-
equipped maternity clinic, or a complex of mud office-
buildings wired for telephone – would appear alongside the
awesome figures of enthroned deities. These large
two-storied religious buildings crowded with sculptures
and paintings were a community creation; intended as an
offering of the community's labour and imagination, they
were left to fall to pieces after completion. They were a
typical African mixture of the sacred and profane,
reflecting the whole of life:

> When you see *Mbari* you will come to understand that
> four things are included: things which are good and/or
> beautiful; things which terrify; forbidden things; and
> things which cause laughter.[14]

*Most popular and commercial
painters are men. A strong,
independent woman who breaks the
social code is half admired for her
freedom, half despised for her
'looseness'. Bar painting at Bo, Sierra
Leone. Photo: Ben Oelmann.*

Modern lifestyle and technology were celebrated among the
good things, as a declaration of faith in the future. But
paradoxically they stood for the very forces which would
cause the decay of *Mbari* as a cultural creation.

If it is surprising to find these commodities portrayed in

105

Man at the telephone in an office building. Mud sculpture in the gallery of an mbari, *Umuofeke Agwa, Nigeria. Photo: Herbert Cole.*

106

a spiritual space in all their material ordinariness, the opposite is true of shop signs and commercial painting: they make the ordinary look extraordinary. The face of a watch, the sheen of a two-piece suit, signifies the modern. At the same time they bring to mind a period before modern advertizing when the services of a shop were announced by a visual anecdote or the gigantic replica of a commodity. These signposts are only found in the most popular parts of African cities and in small towns; already they are being superceded by modern ads conveying only the abstract power of brand names.

The very vitality of this portrayal of commodities produces ambivalent feelings, especially in relation to societies like those of Africa which have always given greater value to human relations than to material things. Does it express the marvellous, or the banal? Does it signify an unconstrained appetite for the future or a relentless

African barber. Sign by Willy Arts, Nigeria.

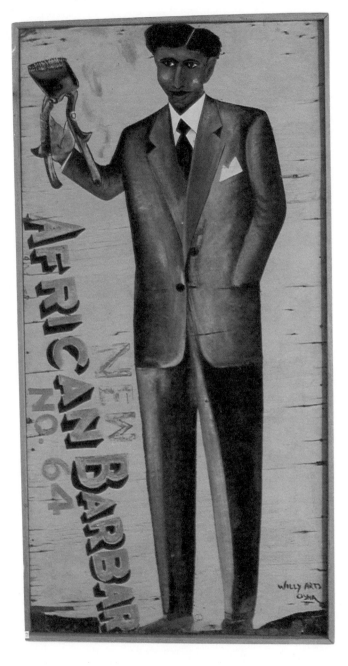

historical process in which all our moods are increasingly expressed in the world of objects?

Something of the same enigma can be felt in the objects which children construct and use in their play. There must be few people who do not feel a surge of pleasure as soon as they see the way an African child has transformed some waste tin, wire and raffia into a lorry or a plane. In their economy of statement, elegance, the way the idea of a 'car' or 'helicopter' can be communicated without pedestrian realism, they have a true aesthetic sense. They could hardly show more clearly the paradoxical relationship betwen modernity and traditional values. On the one hand children are fascinated by the latest inventions, which awaken universal desires. 'With this plane I'll go to see the moon,'

'What the year will bring is found in the games of children' (Songay proverb). Ivory coast. Photo: Chantal Lombard

one small boy said, 'and I won't get into a car any more.' On the other hand they do not relate to them as consumers. They want to appropriate them in the fullest sense, to produce them. According to Chantal Lombard, in her perceptive study of the toys and games of Baule children of the Ivory Coast:

> While the European child accumulates toys (produced by industrialism), collects them, 'exhibits' them, the Baule child has another attitude. For him the toy expresses, not his desire *to have* but his desire *to be*.[15]

Baule toys only last a few hours. The children could use more durable materials but they do not because they are more interested in aesthetics and expressivity, in representation, mastery, not in personal property. (The wire technique, which stresses the mobility and dynamism of the object rather than its consumer durability and is curiously reminiscent of computer graphics, may derive from traditions of basketry.) Chantal Lombard quotes Roland Barthes' observation that toys in Europe make the child 'a little proprietor, a user, never a creator.'

Not only is the child's relationship to the toy different; so is the relation of child's play to the adult world:

Niger. Photo: Gerard Payen

In making the small-scale models of [these] prestigious machines, the child possesses a world superior to that of adults; he not only plays all roles at once – driving the plane, the car and the bicycle – but he is also capable of producing the object, which the adult cannot produce, can barely buy or even use. The children express in their games the dreams of the community ... Children feel changes quicker than the adults. This phenomenon was also noted by Boubou Hama, who used to quote a Songay proverb: *'What the year will bring is found in the games of children'*...[16]

In modelling bicycles, tape-recorders or sewing machines children are not merely expressing wonder but are also acutely conscious of poverty and the realities of 'underdevelopment' as something determining their own lives and those of adults. As a Kenyan child wrote in a school essay, on the theme of 'My Home':[17]

SANYU COMPOSITION

14-9-1977

I Live in Mathare Valley with My family of four brothers. Six Sisters and My Parents. Our house is built of torn backing box Papers both Walls and the Roof it has no any Compartment. What I Want to do When I am a grown up Person. is to work hard and get employment after Which I build a house for my Parents Which will be enough for both of us and not of torn backing box Papers but of Modern type. From which Parents will live a happy life.

Eastleigh (9½ years

Ivory Coast. Photos: Chantal Lombard.

Hiroshima, 7 August 1945.
Photo: Mitsugu Kishida.

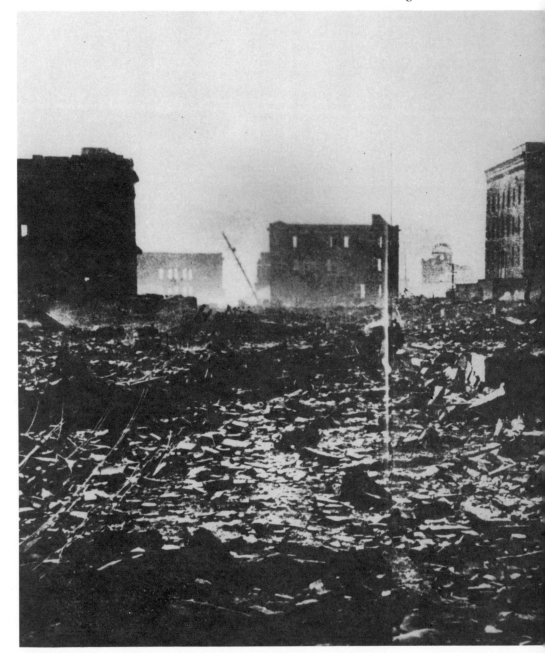

112

CHAPTER 4

TO RID THE WORLD OF NUCLEAR WEAPONS: HIROSHIMA

W hat does the word nuclear bring to mind? American schoolchildren were asked in a questionnaire sent round by the American Psychiatric Association towards the end of the 1970s. One child replied:

> Danger, death, sadness, corruption, explosion, cancer, children, waste, bombs, pollution, terrible, terrible devaluing of human life.[1]

Nuclear power, the nuclear bomb, produces the most powerful mental images in practically everyone. It looms in our consciousness, waking and dreaming, prompting some of us to protest, some to cynicism, prompting some to thoughtfully and imaginatively consider its implications for – and others to blot it out from – the everyday way of living from which it seems so terribly remote. The nuclear threat remains omnipresent and overwhelming. But while for the vast majority it remains a matter of generalized mental images, for a small minority – the survivors of the atomic bombing of Hiroshima and Nagasaki – it is a matter of actual and very specific memories.

The relationship between the local and the global – one of the themes I wished to explore in this book – reaches a remarkable intensity in connection with the nuclear issue. The actual experience of nuclear attack – a matter of obvious importance to everyone on the planet – is limited to a small, localized and dwindling number of people. The reports of what they saw and felt should be among the most precious and widely known of contemporary documents. And yet they are scarce. As far as the paintings and drawings produced by survivors are concerned, the fact

113

that they exist at all is due to the initiative of one private citizen – a broadcaster at the Hiroshima TV station – who, nearly thirty years after the event itself, had the idea of inviting viewers who had been in Hiroshima and Nagasaki to draw their memories. Apparently no one – government or international agency, peace group, therapist or private individual – had thought of it before.

The images that poured in – some 2,200 to date – are almost unbearable to look at, such is their intensity and directness. What they make one feel about the possibility of nuclear war or accident hardly needs to be put into words. But there are things that can be said about the existence and significance of these images, both in themselves, and in relation to other images generated in the 'art' and in the 'media' worlds by this unprecedented event.

●

Can nuclear war be depicted? Clearly in the last few years, with the escalating arms race between the superpowers and the proliferation of nuclear weapons, reference to the nuclear issue in the work of artists has increased dramatically. The appearance of the survivors' paintings has contributed to this too. In the entertainment world, the various conventions of TV drama, for example – plot, acting, special effects, make-up, etc. – have been stretched to such limits that they almost make fun of themselves. Earlier, specific reference to the Bomb in 'fine art' (as opposed to cartoons, posters and other agitational forms) was rare. Nevertheless there are two examples which show remarkably different approaches.

The *Peace Mural* by the Mexican communist painter Diego Rivera was produced late in his life in 1952 and is

Diego Rivera, Sign For Peace, *mural painted in Mexico, 1952.*

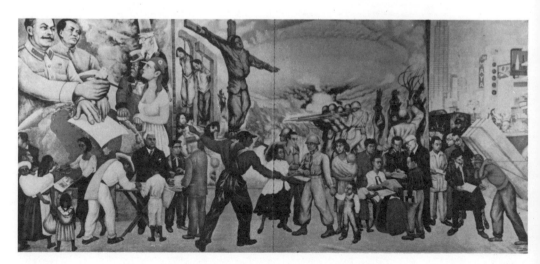

Andy Warhol, Atomic Bomb, *acrylic on canvas. Produced in New York, 1965.*

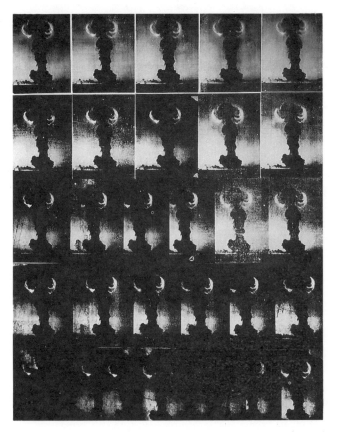

now located in Beijing, China. Its rather demagogic stylistic devices aim to encourage the viewer to sign the Peace Petitions issuing from the socialist countries at that time. Rivera links the Bomb directly with Western imperialism. Andy Warhol's painting, coming from New York in 1965, has completely the opposite of any mobilizing intention. In fact it seems to gain its effect by playing on the sadness of the *immobilizing* effect of images repeated in a mindless way by the mass media. As a comment it remains apt; even today a full-colour reproduction of the mushroom cloud is available along with other imagery in high-street poster shops.

Though opposites, both these images seem equally removed from the reality of a nuclear explosion. Among professional painting it is, not surprisingly, two Japanese artists who probably came closest in that postwar period to depicting the experience of a nuclear attack. Toshiko Akamatsu and Iri Maruki, a wife and husband, were in Tokyo on the day of the bombing. But they had relatives in Hiroshima and went there immediately they heard the news. They stayed and helped in rescue work. The

115

Toshiko Akamatsu and Iri Maruki.

experience affected them so deeply it was three years before they could begin to paint. They decided to use the traditional Japanese method of screen painting and traditional materials – rice paper and India ink. ('We did not use Western materials like oil paint because the bomb was not dropped on a Western people.')[2] Their paintings toured the world in the cause of peace in 1958. They were brought to Britain, for example, in an exhibition sponsored by the Anti-Hydrogen Bomb League, with a catalogue foreword written by John Berger.

In attempting to deal with this subject Maruki and Akamatsu drew on the traditional Japanese concept of the ghost play, *Sarayashiki*, which they explained themselves in the following way:

> In this play a girl is killed by her master and lover because she accidentally breaks one of a set of plates belonging to the family. Her ghost, like that of all oppressed women of feudal Japan, expressed the indignation and anger that women dared not show in their lifetime ... old Japanese ghosts – an aggregation of congealed resentment, a suffocated and unuttered voice, expressing the flaring indignation that lies buried deep in the heart...[3]

In other words, while showing the carnage and the dead bodies, they also wanted to express resistance, and condemnation of the bombing as a crime against humanity.

Though appreciated, Maruki and Akamatsu's paintings were criticized by survivors when they joined the crowds who flocked to see the pictures on their tour of Japanese cities. They said things like: 'You should have painted the shreds of skin far redder ... people were vomiting blood. Why didn't you show it?'[4]

116

A small section of Akamatsu and Maruki's Hiroshima panels, begun in 1948. Rice paper and India ink. Now located at the Maruki Gallery for Hiroshima Panels, Higashi-Matsuyama, Tokyo.

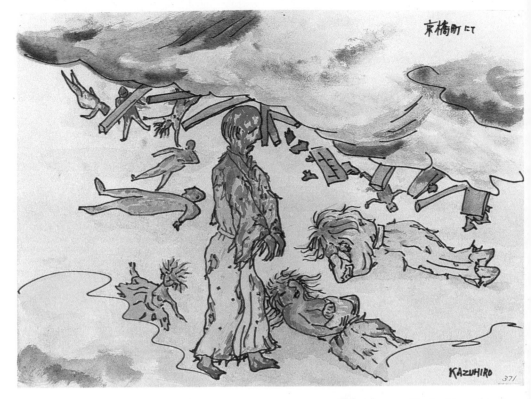

'What I saw at Kyobashi-machi ...'
By Mr Kazuhiro Ishizu, now 77.

This is exactly what the paintings by survivors do show.

While the screen paintings tend to generalize, the survivors' paintings – together with their captions which are an inseparable part of their meaning and are often written on the picture in the customary Far Eastern way – are very specific about the nature of the suffering. To find a vehicle to convey their emotion the professional painters looked to the past, to a cultural tradition, to a powerful but conventionalized form of visual epithet for expressing collective sorrow and indignation. There was no alternative but to look for a cultural prop. Some commentators on the survivors' paintings themselves have also reached for parallels with the past, comparing them with medieval depictions of Hell for example. But this misses the point. The whole *raison d'être* of the survivors' paintings is to show what is new.

Haunted by a traumatic memory, the eye-witnesses make no attempt at an overall view or any kind of summing-up. They are locked inescapably to a locality, to personal and social relationships, as we all would be in the event of a nuclear attack. They walked a few hundred yards here, a few hundred yards there. Without any psychological preparation they saw, not only the instantaneous destruction of their environment, but the slow subsequent disintegration of people around them in the most undignified ways which could not even have been imagined. No such attack on the human metabolism had ever been seen before. In the professional painters' work, in medieval depictions of Hell even, the artist's accumulated skills and practice of observing and depicting the human body seem to mean that some beauty and sensuality always comes through. But the survivors' pictures are unrelieved significations of shock and heartbreak. Undoubtedly one of the reasons they are so powerful is because of their rudimentary, unpolished style which itself seems to echo the way the familiar urban infrastructure had been obliterated and human behaviour reduced to helplessness. All culture – medical, artistic, productive, political – is wiped out.

By comparison therefore with professional art, the outstanding characteristic of the eye-witness paintings is that they concentrate on *facts*. They are not concerned with sensationalism, rhetoric, metaphor or synthesis: even overpowering emotion they express not by turning inward, but by looking outward and recording what they saw. But, interestingly and paradoxically, if they are compared with today's universal visual medium of supposedly factual information – photography – it is their emphasis on *feeling* that becomes outstanding.

Quite a large number of photographs were taken of the destruction of Hiroshima and Nagasaki, some by Japanese photographers who lived through it in the same way as the eye-witness painters, others by visiting photojournalists, and others by the United States armed forces. Naturally they are vital documents, often obtained with bravery, and they have a complementary value to the paintings. But nowhere does the detached nature of photography, its tendency to look on 'from outside', which was suggested in the introduction, become clearer than by comparison with the paintings. While the paintings select the incidents which struck each individual most powerfully and along with the caption describe the feeling it aroused, the photographs inevitably stress the surface materiality. They have a forensic aspect: all the dust and blood is shown. The part played by time, and above all by memory, in the production of the paintings gives them quite a different relationship to the significance of the event. The material mess, caught instantaneously in the photos of 1945, has long since been cleared up. Hiroshima in fact has become a byword for the human capacity to rebuild from total destruction. But the marks in the mind are still there.

The paintings tell us more about people's relationship to the event, and even about the relationship between these unknown, faraway individuals and ourselves. In a way, the crux of this whole experience is very finely balanced between remembering and forgetting. What the individual would rather forget – in order to have the chance of getting on with his or her own life – the species must remember. What is so hard for the individual to forget is equally hard for people in general to remember. In fact it would appear that there is no forgetting on the individual level, except by overcoming the repression, the privatization of the experience, through letting it out in the cathartic release of *reminding* the rest of us, as happened with the Hiroshima painting thirty years later.

Nevertheless, the fact that we can see even the photographs today is due to the same active conscience which produced the paintings. It is due to the private initiatives and voluntary work by thousands of Japanese citizens who came together specifically to produce an extraordinary book: *Hiroshima – Nagasaki: A Pictorial Record of the Atomic Destruction.* They sifted through four thousand photos by both Japanese and American photographers and put them together with a selection of the survivors' paintings. The attitude of the American military had been to suppress most of the visual records of the bombing. An official US film, for example, taken by a military documentary team soon after the explosions and

A man who died apparently on the spot lies with one hand pointing to the sky. Blue flames rise from his fingers, and liquid the colour of India ink drips down. By Mrs Nobuko Takakura, now 58.

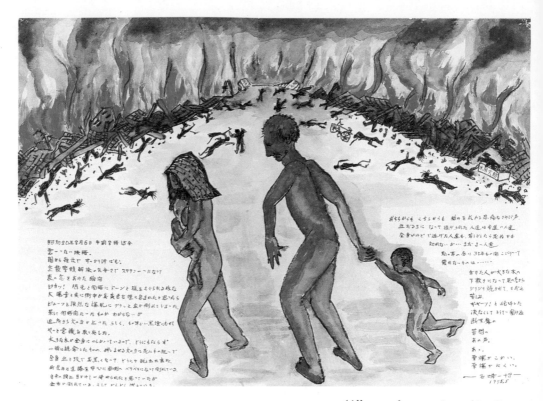

'All around were voices asking for help. We tried to find shelter, our clothes burnt off us, our bodies covered with blood, and choked with smoke.' By Mr Kazuhiro Ishizu.

122

showing in detail the physical destruction and the terrible suffering of the survivors, was locked away by the Pentagon for forty years. When I saw parts of this film on TV in November 1983, one of the things which appalled me most was the way the people of Hiroshima and Nagasaki had been left to fend for themselves. Despite the Japanese surrender, people were still camping in the radioactive ruins months later. The interest of the American officials, though not of the film-makers themselves, was in the effect of the Bomb for future military planning. It made me realize that in practice, *only popular initiatives have been able to reveal the meaning of this event for the mass of ordinary citizens* – in Japan, and by extension, in the world.

The idea for the book also came from one man. On a visit to Hiroshima with his children, he noticed the way the pupils of a secondary school were exchanging materials about the bombing with students of other schools in Japan. From the beginning the book was conceived as a *gift,* 'to be sent to children and fellow humans throughout the world'. From the first meeting of an editorial and planning committee in March 1977 until the moment, little more than twelve months later, when a 350-page book in colour and black-and-white was published, almost all the work (which included such time-consuming tasks as tracing the photographers who had been in the two cities and reprinting from their original negatives) was done voluntarily. Individual sponsorship has paid for the book; it has never been for sale. Copies are sent to anyone who can make use of it, show it in schools, publicize it, and so on.[5] Later in 1978, some of those who helped produce it formed a delegation and raised the money to take the book to the UN General Assembly during the first Special Session for Disarmament. One of those who made the trip commented:

123

I was impressed with the fact that the Americans knew almost nothing about Hiroshima and Nagasaki. I should say they were not informed of the facts about them. Only a limited number of Americans who were the leaders of the peace movement and their followers had seen a few photographs of the atomic destruction. Two-thirds of the people whom I met at the exhibitions of the panelled photographs held at street corners did not know about the historical evidence of *Hiroshima-Nagasaki.* Namely, they knew nothing about the fact that the government of their own country dropped atomic bombs on Hiroshima and Nagasaki. As a result, I felt keenly the necessity to show them visual records of the atomic disaster.[6]

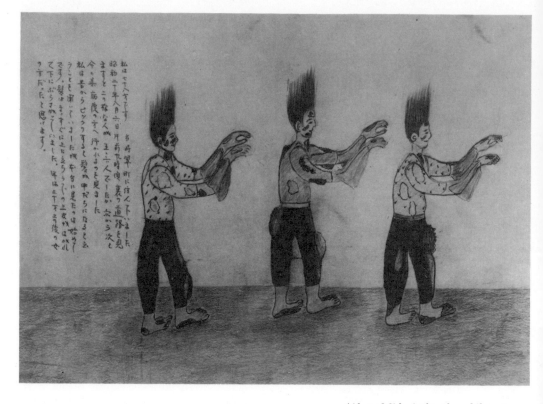

'Along Midori-cho, three kilometres from the hypocentre, about 9 am on 6 August. Their hair literally stands on end, the skin on their arms hanging like rags. These three stand for hundreds…' By Mrs Asa Shigemori, now 89.

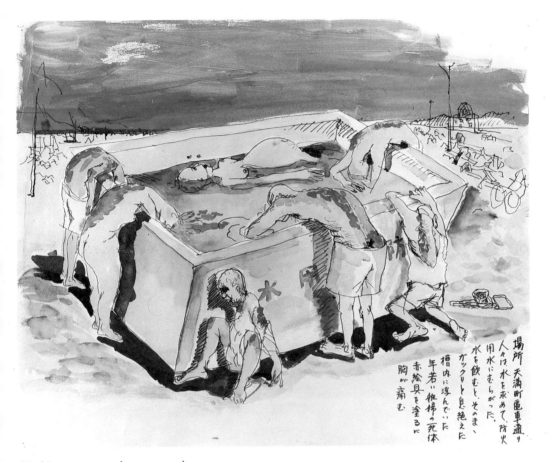

場所　天満町電車通り
人々は水を求めて、防火
用水にむらがった。
水を飲むと、そのまゝ、
ガックリと息絶えた
槽内に浮んでいた
年若い姙婦の死体
赤絵具を塗るに
胸が痛む

'Seeking water, people swarm to the
water tanks and die even as they
drink. The body of a young pregnant
woman floats there. It was so painful
for me to paint the red, and to
remember…' By Kiaki Ono, now 56.

125

(1)

昭和20・8・11日朝私が見た、妻（幼才）の焼けただれた顔・体の状態・

私は軍人で8月5日軍の命令で四国高松に出発、8月11日広島市牛田の自宅に帰へった、

（一）瞼（まぶた）は焼けただれて図のように垂れ下り赤みが、はれあがって、おばけの様相であった・

（二）唇（くちびる）外方（そとむき）に、腫（はれ）れあがり猿（さる）の口のようであった、

（三）全身の皮ふは・やけただれ蟹（かに）の甲らのようにぶつゝくでウジ虫がわいていた・

蚊張（かや）をつっていたが全身にウジがわいた・

昭和20・9・8日死亡・油をつけたり、川の藻（も）をはったり種々と手をつくしたが、

126

A-17

The production of the paintings likewise has to be seen as a popular initiative and a collaboration between those who produced them and those who asked for them. Without one or the other they would still not exist:

One day in May 1974 Mr Iwakichi Kobayashi, an old man of 77 wearing *geta*, visited the NHK (TV) studio in Hiroshima. He had a single picture with him and said that the TV drama *Hatoko no Umi*, then on the air, reminded him of the Atomic Bomb explosion. He showed us his picture titled 'At about 4 pm, August 6 1945, near Yorozuyo Bridge'. In the simply and vividly drawn picture were countless numbers of people suffering from burns and thirsting for water. There was also a figure of a young lady covered with a burned sheet of tin-roofing lying on the river bank. Mr Kobayashi explained that he was at the railway station when the Atomic Bomb exploded. He was looking for his only son when he witnessed the scene he had drawn. Usually we think of the Yorozuyo Bridge as an ordinary bridge we cross and we do not pay any attention to it because Hiroshima has many rivers with similar bridges. So we were awed by the extraordinary power of Mr Kobayashi's picture and by the vividness of his memory even after almost thirty years ... NHK broadcast in June 1974 a local morning programme titled *A Single Picture* which was based on Mr Kobayashi's drawing. With that programme we started an appeal 'Let us Leave for Posterity Pictures of the Atomic Bomb drawn by Citizens'.[7]

After the programme paintings and drawings began to pour in. 'It was as if a dam had broken.' Some were mailed, others brought in by hand. Some showed their pictures 'explaining them feverishly, sometimes in tears'. They were done in pencil or crayon, watercolour, magic markers, coloured pencils, India ink – and on whatever was to hand: drawing paper, backs of calendars, bills, or paper used for covering sliding doors. 975 pictures were collected in the two months between June and August 1974. By 1983 there were 2,200, and today they are still being sent in. Mrs Haruko Ogasawara wrote: 'I drew pictures again this year because I want to go on handing down that horrible scene of the A-bombed city which will remain in my memory as long as I live.'[8]

Though it depicts extreme misery, the art of the eye-witnesses is not concerned to present people as victims. All the pictures are variations of 'I saw this', 'I was there'. The recording of these moments becomes an act of respect

'The condition in which I found my 40-year-old wife on the morning of 11 August 1945. She was badly burned and had developed running sores.

I was a soldier and had left for Takamatsu in Shikoku by orders of the army on 5 August. So I returned home to Ushita in Hiroshima City.

1. She looked just like a ghost because her eyelids were badly burned and swollen.

2. Her lips, swollen and protruding, made her mouth look like a monkey's.

3. Although she was under mosquito netting, the skin of her whole burned body on which maggots were breeding had the appearance of the crust of a crab.

She died on 8 September 1945, even though I applied oil, seaweed, and tried every other means I could think of to save her life.' By Mr Fusataro Tanimine, now 86.

127

for the ones who died (this the painters themselves say, often ending their captions with the words *gashoo* or *gashoonembutsu* meaning hands folded in prayer for the dead), and an act of resistance. Their images will go on disturbing the fait accompli of the bombing, of disposing of it with a few well-worn phrases or images of the kind in the Andy Warhol painting, so long as they are presented in the spirit of the act of collective conscience which brought them into being.

'After a few days we carried the injured people who had been on Kanawa Island to the Otake Marine Corps base. Each motorboat pulled five rafts as this picture shows. On each raft were one NCO, three soldiers, fifty injured people, and about twenty of their relatives taking care of them. We could do nothing for the injured people but give them water...' By Mrs Yoshimi Hara, now 66.

128

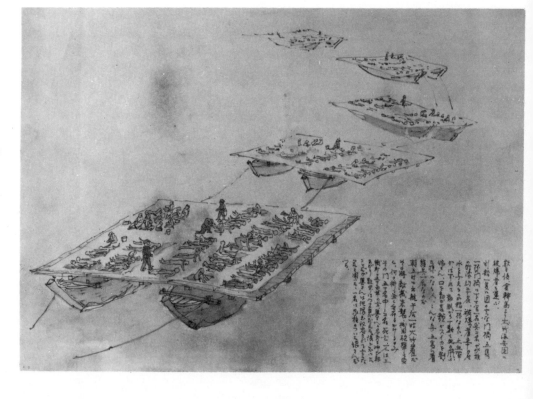

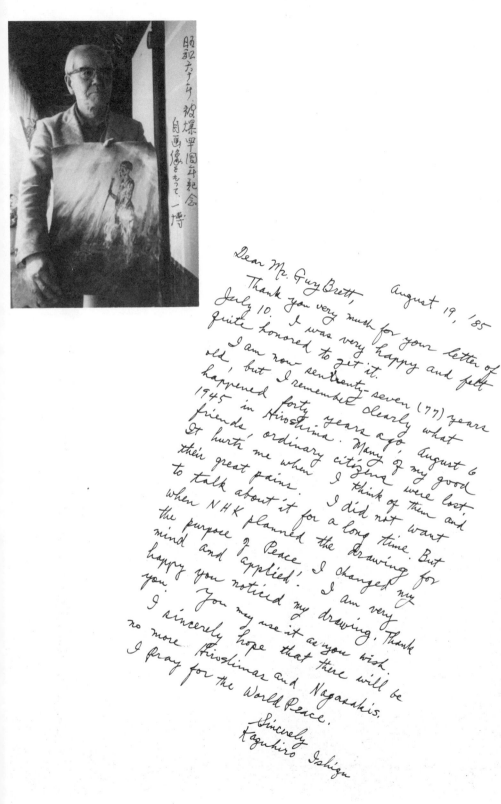

昭和六十年 被爆四十周年記念 自画像をもって・一博

Dear Mr. Guy Brett, August 19, '85

Thank you very much for your letter of July 10. I was very happy and felt quite honored to get it.

I am now seventy-seven (77) years old, but I remember clearly what happened forty years ago, August 6 1945 in Hiroshima. Many of my good friends, ordinary citizens were lost. It hurts me when I think of them and their great pains. I did not want to talk about it for a long time. But when NHK planned the drawing for the purpose of Peace I changed my mind and applied. I am very happy you noticed my drawing. Thank you. You may use it as you wish.

I sincerely hope that there will be no more Hiroshimas and Nagasakis. I pray for the World Peace.

 Sincerely
 Kazuhiro Ishizu

129

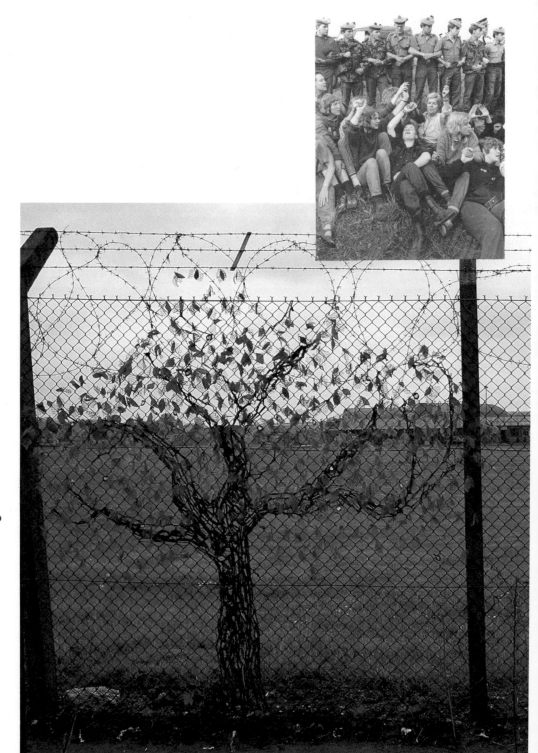

CHAPTER 5

TO RID THE WORLD OF NUCLEAR WEAPONS: GREENHAM COMMON

In August 1981, forty Women for Life on Earth walked the 110 miles from South Wales to the USAF/RAF base at Greenham Common, the proposed site of 96 American cruise missiles. Four women chained themselves to the perimeter fence and demanded a TV debate on nuclear weapons. When this brought no response, some of the group decided to stay put. This was how Greenham Common Women's Peace Camp began. If the 'art' produced at Greenham Common, the special forms of visual expression which have accompanied the actions – have *been* actions in themselves – are compared with the drawings of the Hiroshima survivors, there is an obvious difference. The women at Greenham have not tried to move people by depicting the reality of nuclear war, which they could not possibly emulate, but by touching their desire for life and beauty.

After looking at the Hiroshima pictures it is hardly necessary to ask why the nuclear bomb should be the focus of fears reaching down to the depths of the psyche. But it is worth examining these fears a little more carefully to see if they can be divided into parts which can be linked with other realities, rather than treating 'nuclear energy' as one great principle of evil, like the Devil. After all, a number of years ago the word 'nuclear' would probably have aroused different associations in the mind of the child quoted at the beginning of Chapter 4, associations of modernity, science, cosmic forces. Nuclear energy is part of our consciousness not only as a nightmare. The scientific discoveries which led up to the splitting of the atom and the making of the Bomb were the same ones which changed our whole view of matter and energy, discoveries echoed throughout modern culture. In the visual arts, for example, artists went

Greenham Common, 1982. Photo: Lesley McIntyre.

Tree woven into perimeter fence, Upper Heyford, June 1983. Photo: Ed Barber.

131

through a parallel process by breaking down the homogenous surface of classical art into what might be called the 'elementary particles' of colour and form, and created what is broadly known as abstract art. The result was the release of a new kind of visual energy which was always seen as a liberation from the relative weight and dross of the old view of matter and the old practice of painting. The word 'nuclear' is associated with a dynamic view of reality as a play of forces and reactions, flowing across the old boundaries which delineated and separated objects from one another.

Suprematist drawing by Kasimir Malevich, one of the pioneers of abstract art. Russia 1920.

It is all the more fateful, then, that nuclear energy and weapons should come to stand for the complete antithesis of all this: as the most potent symbol there is of the power of the authorities, of the state, of the rigidity of the status quo. The presence of US bases in Britain, the installation of new weapons without public debate, the official attitudes to nuclear war and civil defence, pollution spreading into ever more intricate structures of the world and our bodies, the secrecy surrounding the whole subject, instil a feeling of utter powerlessness. In these actions the state sets itself against the mass of people as never before; it assumes an acquiescent population, even a victim-population, since governments can coolly plan the sacrifice of tens of millions of people to defend what they define as 'national interest'. Although Greenham Common is specifically a protest against war and nuclear weapons, and this dictated the site of direct action and the particular discomforts the women took on, it rapidly came into confrontation with the whole system of values of which the Bomb is part, and which women felt they had, historically, no part in creating. They responded by themselves proposing a whole set of values, both personal and public, from forms of protest to attitudes towards the landscape, from ways of living to forms of communication – and of art. If the Bomb is a great cause for our fear of the authorities, it is also paradoxically a galvanizing force against those fears. For as one of the women lawyers involved with defending Greenham protesters remarked: 'Why should courtrooms worry anyone when the threat of utter destruction hangs over us?'[1]

●

I cannot write about Greenham Common with inside knowledge, only as one of those countless people who feel that something new has been happening there, a new kind of manifestation which is not political in the narrow sense,

132

with well-worn forms of protest, slogans, narrowing oneself down to apply pressure at a particular point, but in which people wanted to give and to represent the whole of themselves. They are not an audience for speeches, or even the music of sympathetic rock groups. They have created their own forms of expression which are both individual and collective, which arise equally from the strength of their own feelings and from the nature of the site. The fact that these expressions – such as the decoration of the perimeter fence or the weaving of webs of wool – have much in common with some recent radical forms of art is particularly fascinating, with the difference that instead of being limited to the small groups that interest themselves in avant-garde art, here they became *signs* capable of acting directly on public events.

The site of Greenham Common is one of the reasons for its special impact on people's consciousness. Like the other nuclear installations in Britain and abroad which have been picketed, Greenham reveals the striking and paradoxical way in which the small-scale goings-on and concerns of a locality today are connected with the global operations of the superpowers. On the one hand this patch of English countryside is a small link in a vast system, the means of destroying millions of people (and land and buildings) in a faraway place, controlled from another place equally far away. On the other hand, the superpower has to come down

Photo: Tim Malyon.

133

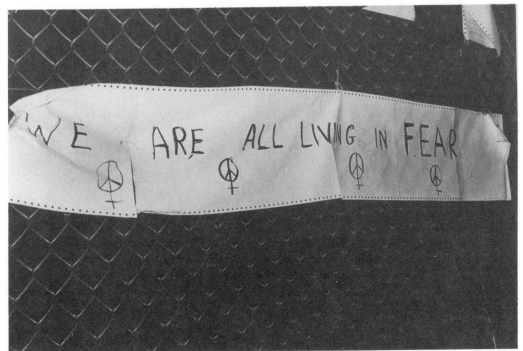

to the local scale, to face-to-face confrontations over a piece of fence, to the irritations of local bye-laws and so on. (The peace women appealed to the ancient custom that the common at Greenham belonged to everybody and they could not therefore be evicted. Some local residents, narrowed down to the micro-world of their own properties, could only see the issue in terms of tidiness and 'hygiene', and tried to reverse these ancient rights.)

In the city, traditional site of demonstrations, the installations of nuclear war are less visible. They become part of culture, wrapped in the cocoon of familiar streets and buildings. In a way, the cities today are as self-absorbed as remote villages were in the past. In the countryside these installations stand out sharply, producing contradictory feelings which are almost sensory: you feel the vast geographical reach of military violence, the meaningless-ness of rural peace, and at the same time the beauty of the planet which is threatened. The very new is confronted by the very ancient, in a way which can stretch the imagination to take in this reality. These facts are, so to speak, latent under the humdrum surface of normality (which the powers that be always do their best to preserve). It took the Greenham women's courageous break with the normality and domesticity of their own lives – leaving home, perhaps children, and living rough for months on end – to open the whole question out. Stepping outside of their place in the 'system' enabled them to see both the reality and the mystique of power:

> Taking down the fence was, for me, a most powerful celebration, an expression of 'No' ... I knew when I was up there that we were opening up something very big, exposing a nerve so sensitive and afraid without its protective layer, allowing the fresh and healing air to

'This cloth is from an Inca archeological site in Peru. It is 2200 years old.' Greenham perimeter fence. Photo: Tim Malyon.

134

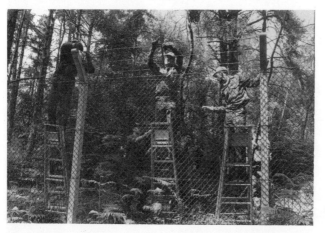

American soldiers reinforcing barbed wire. Photo: Lesley McIntyre.

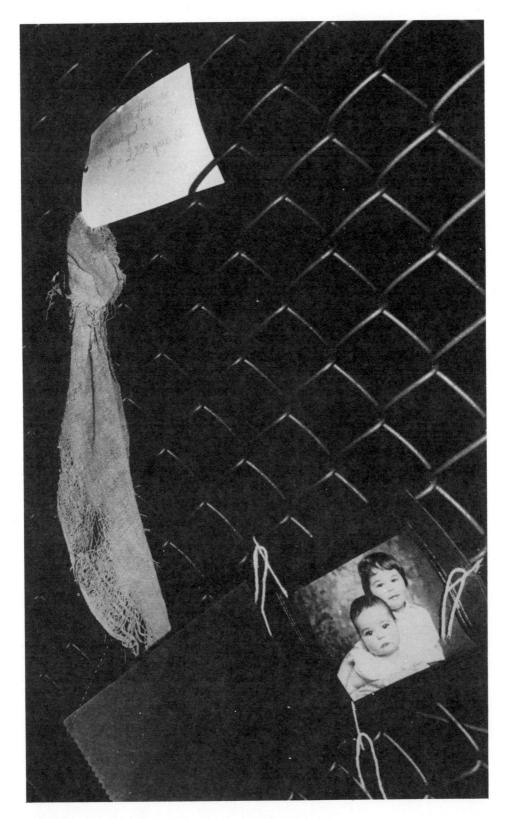

pass through, being able to see clearly the causes of all this pain and illness and for the first time staring it right in the face, able to confront and deal with this monster machine.[2]

'Taking down the fence' was repeated at all the different points in the apparatus of power where the women found themselves as a result of their action: up against the police and soldiers at the base itself, in the courts where some women were charged with 'causing a breach of the peace', in the prisons, and in front of the world media. Their behaviour always showed up the way our professionalisms, jobs and roles fit together into a system of established power which splits our personalities and prevents us thinking and acting like sane and whole human beings. This was especially poignant in the staid old theatres of the courts:

Woman after woman gets up to explain what her action means to her, recounting dreams, putting direct questions to the magistrates, telling personal histories and discussing personal priorities.[3]

I couldn't believe, then, that the magistrates would not simply step down from their table and join us.[4]

In the media verbal statements like these can very easily be distorted and trivialized by editing, and here it was probably the mass actions, because of the way they expressed a real, shared feeling through new visual symbols, which had the same effect in another form.

Through a protest against the latest type of nuclear weapons came a challenge to alienation in all its forms, and both were inseparable from the growth of women's consciousness of their own strength. As the American art historian Arlene Raven wrote in another context:

136

... a woman's saying *I am*, I know myself, I understand on the basis of reality how I can act in the world, and I feel a fundamental optimism – a grasp upon my survival as a model for human survival – is saying something which challenges the existing and prevailing world view.[5]

●

A number of professional artists have stayed at Greenham and worked there. But in suggesting links between the Greenham actions and some recent radical forms of art, I

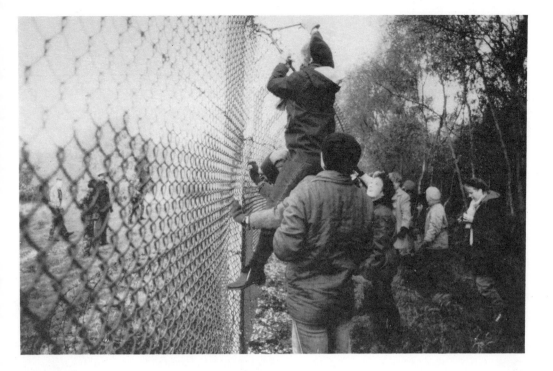

'I knew when I was up there that we were opening up something very big…' Cutting the perimeter fence, October 1983. Photo: Paula Allen.

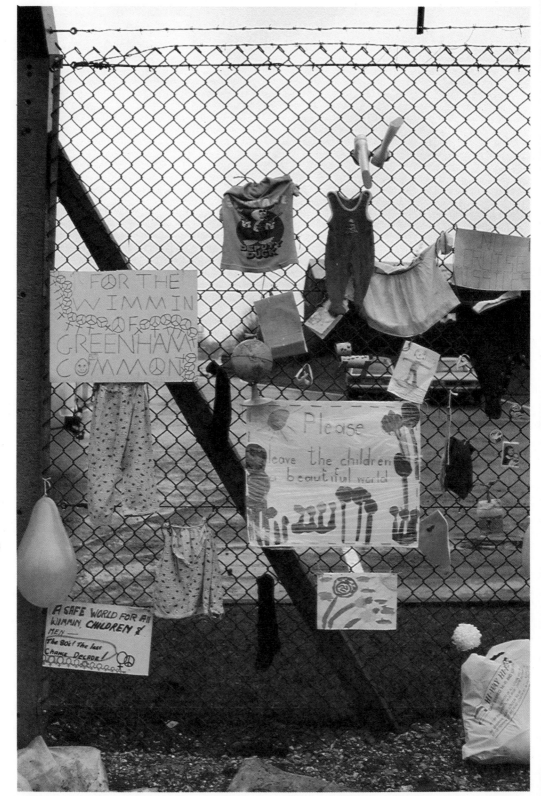

138

Greenham 12 December, 1982.
Photo: Ed Barber.

am thinking of something much more complex and fascinating than a question of direct influence. Certain ideas have been in the air, like seeds. But nobody could have suspected the kind of fruition they would come to when grasped and exercized by thousands of people from the promptings of their own feelings. For the actions at Greenham were not entirely spontaneous and not entirely organized. The ideas were imaginative and unconventional, apparently 'crazy', but also popular and sensitive to a mass desire. How else could thousands of people who were 'strangers' to one another, who do not think of themselves as 'artists' and were not directed by any central person, express their individuality in ways which together could take on symbolic power not seen before? In these circumstances the two sides of art which have become separated, met and fused: art as the specialized preoccupation of a small minority, and art as the need to give form to one's feelings and ideas, which everyone possesses.

On 12 and 13 December 1982, 30,000 women came to Greenham Common. Responding to an idea communicated by the 'telephone tree' (one person calls two others, they two more and so on) and by circular letter, they joined hands around the nine miles of perimeter fence to 'embrace and close the base', and they decorated the fence with things they had brought with them or made on the spot, things that meant 'life'. Valued personal possessions, photos of loved ones, children's clothes, paintings, poems, messages: the variety was endless. And so was the range of individual expression, from laconic humour to poetic fantasy, straightforward simplicity, rage, and the most precious and intricate constructions. Many surprising and eloquent new meanings came about by the chance juxtaposition of people's contributions. The fence, in other words, became a giant collage. Unlike the other forms of popular expression in this book, which are direct representations in the traditional sense, the fence at Greenham realized, even if unselfconsciously, the modernist aesthetic of creating new meanings by combining mass-produced objects and mass-reproduced images, and by placing everyday objects in an unexpected context where they become powerful 'signs'. Taking a teddy-bear from a child's room and placing it in view of the silos of nuclear missiles is as eloquent as writing a poem. Even the given ground, the mesh of the fence, becomes a symbolic form because of the things pinned to it or woven into it. An art reproduction, a Picasso postcard, is part of someone's vision of life. The Greenham fence amplified the dresser-tops and notice-boards of cherished images that almost everyone has in their houses.

A Picasso postcard ... Photo: Jenny Mathews.

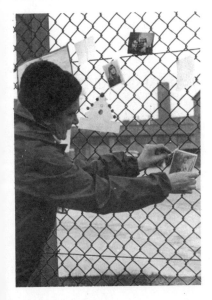

139

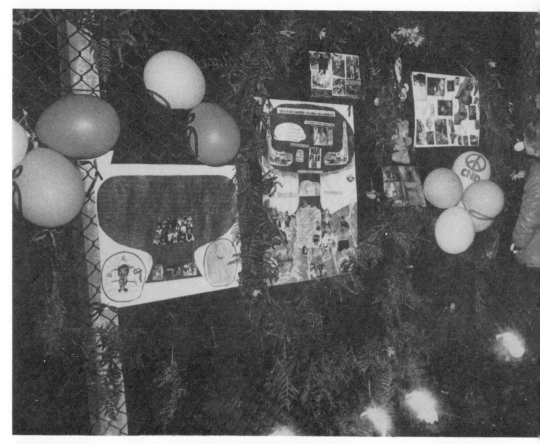

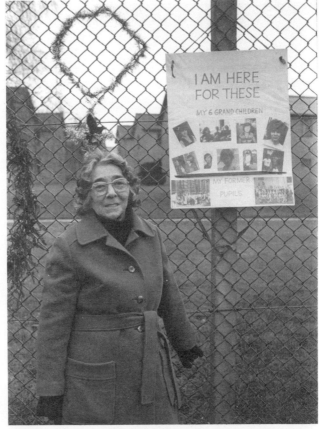

A small fraction of the messages decorating the nine miles of perimeter fence, 11-12 December 1982, when 30,000 women came to Greenham Common.

141

'THINGS THAT MEAN LIFE . .'

Photos: Tim Malyon and (top right) Ed Barber.

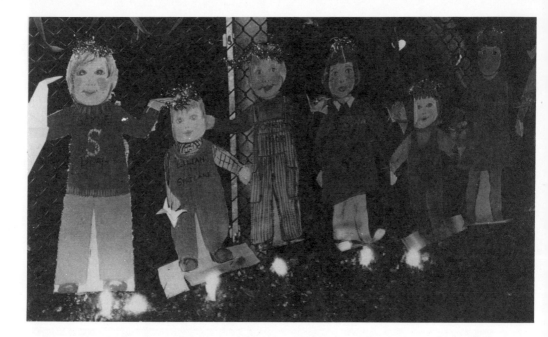

'THINGS THAT MEAN LIFE . . .'

142

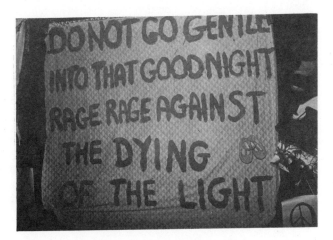

143

*Photos: Tim Malyon and
(top right) Gwyn Kirk.*

'THINGS THAT MEAN LIFE . . .'

Photo: Tim Malyon.

Photo: Pam Isherwood.

144

Photo: Tim Malyon.

If the Earth
were only a few feet in
diameter, floating a few feet above
a field somewhere, people would come
from everywhere to marvel at it. People would
walk around it, marvelling at its big pools of water,
its little pools and the water flowing between the pools.
People would marvel at the bumps on it, and the holes in it,
and they would marvel at the very thin layer of gas surrounding
it and the water suspended in the gas. The people would
marvel at all the creatures walking around the surface of the ball,
and at the creatures in the water. The people would declare it
as sacred because it was the only one, and they would protect
it so that it would not be hurt. The ball would be the
greatest wonder known, and people would come to
pray to it, to be healed, to gain knowledge, to know
beauty and to wonder how it could be. People
would love it, and defend it with their lives
because they would somehow know that
their lives, their own roundness, could
be nothing without it. If the
Earth were only a few
feet in diameter.

The doom-laden myth that in a consumer society people can only relate to things by buying and discarding them, and are incapable of treasuring anything, proves to be untrue at a deeper level that Greenham brought into the open. Art postcards are in fact a very good example of cheap, mass-produced objects which are treasured as an intimate part of a person's identity and individuality. It is the same attitude which brings to light beauty or hidden meaning in the bits of plastic, packaging, discarded imagery and other waste which has been pronounced 'dead' by the profit system. Revealingly, the groups of local residents, police and MOD personnel who came to rip the decorations off the fence a few days after the December demonstration, saw everything, including familiar things they have in their own houses, as 'rubbish'.

Although stylistically different from the other art in this book, the Greenham fence is very much related in being non-hierarchical in form. Each person contributes in a spirit of equality, and there is no privileged viewpoint from which to see the work, or an ideal observer for whose eye a dramatic effect is built up. And yet the whole does have an impact far greater than any part. The really astonishing thing is the aggregate; and its implied meaning, that people's creativity, once released, is endless. This work of art was *nine miles*, not long, but *round...*

It doesn't detract from the power of the Greenham event, or its meaning, to suggest that these ideas have a history. They can be found prefigured in the most imaginative avant-garde art of the 1960s, and in the art connected with the women's movement in the 1970s, both of which came from profound questioning of the status quo in the art world. In the 1960s there was a very widespread desire to go beyond the limits of art activity hallowed by convention, beyond the notion of creativity enshrined in the unique artist who produces commodities for the art market, or objects to be neutralized in state institutions called 'museums'. One of the most succinct and imaginative interpreters of these desires was David Medalla, whose work of the time influenced many artists, though it was ignored by the official art world. His *Stitch In Time* (1968), for example, was an 'environmental installation' set up in various public venues in the late '60s and early '70s. People were invited to sew anything they liked on long sheets of cotton. These were suspended along with scores of brightly coloured cotton reels in a beautiful rope construction, drawing strangers in to take part. An amiable, modest proposal in relation to everyday life became a witty and liberating metaphor in the context of art: 'I wanted to break

146

Stitch In Time, *1968. A work of participatory art by David Medalla in which people were invited to sew anything they liked on long sheets of cotton. Some of the actions at Greenham were prefigured in the radical art of the 1960s and 1970s, which broke with traditional notions of creativity, and the relationship between artist and audience.*

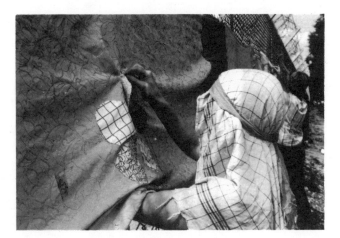

Stitching at Greenham, August 1983. Photo: Raissa Page.

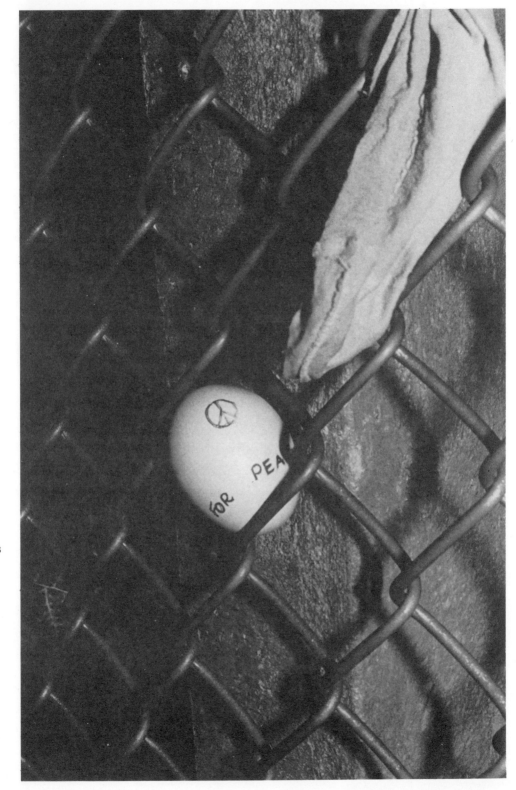

down the invisible barrier between "creator" and "spectator", for art to become a living process in which one, two or several people formulate suggestions that others take up and develop in different directions.'[6]

Some people stayed long and left intricate embroideries, others sewed on small belongings or thrown-away scraps and photographs. The activity of stitching was chosen because it calms and draws the person in to its own rhythm, to concentrate and decide what statement they want to make. Rather than projecting his own singularity and expressive power, David Medalla contrived a subtle framework in which anyone (including himself, incidentally) could practise and think about art as the act of giving oneself.

Anyone looking at the Greenham fence would have been struck by the way the might of the weapons was opposed by the most fragile things: personal possessions, baby clothes, wool. Someone left an egg in the mesh of the fence, inscribed 'For peace'. Aggression was met not by closing oneself in, armouring oneself, but by exposing one's vulnerability, by making visible what the dominating power excludes or denies. This turns what are supposed to be signs of weakness into symbols of strength.

> She will find she is perpetually wishing to alter the established values – to make serious what appears insignificant to a man, and trivial what to him is important.

Photo: Tim Malyon.

Photo: Tim Malyon.

So wrote Virginia Woolf about the woman writer.[7] Also lying behind the actions at Greenham are the struggles of women to project their own voice in a male-dominated world. These intensified and were given a sense of common purpose by the rise of the women's movement in the 1970s, and the specific area of the visual arts was no exception. Though individuals followed up their own interests, there were certain general ways in which the established values were altered in the way Virginia Woolf describes. Whereas the typical male attitude has stressed professionalism in art as a special realm from which the other parts of life are shut out, women made no break between their lifestyle and their art practice, they often extracted meanings from materials directly associated with their lives, not with art history. Where men placed most emphasis on form, women stressed content. Women generally had less time for the system of barriers by which the purity of 'serious' art is maintained: they readily combined pictures with words, and combined elements of theatre, visual art and ritual together in performance works.

149

Crossing the barrier between life and art, and being equally open to the various 'ambiences' (painting, sculpture, dance, music, poetry) in which creative expression develops, is one of the most exciting areas of contemporary art because it leads to the use of metaphor and symbol in everyday life situations, where they can take on remarkable power as they did at Greenham. Leaving aside the more obvious, appropriated, 'literary' symbols such as the Rainbow Dragon Festival of June 1983, there were other actions arising directly from the nature of the occasion and the site: planting peace symbol gardens in patches of scrubland around the fence, the mirror action of December 1983 where 50,000 women encircled the base, reflecting it back on itself with mirrors, and the weaving of webs of wool. These, first used outside the Pentagon, have become the symbol of the women's peace camps. A brilliant realization of the weakness-strength metaphor, they don't meet force with force, but with a very subtle psychic riposte which is essentially sculptural and visual. For the women: threads linking one person to another, linking bodies to the land, both spreading out and protecting, gathering to a centre. For the authorities: an embarrassment to brute force, cobweb messiness, the disturbance of clean demarcations between properties, functions, responsibilites.

Premonitions of these ideas too can be found in art, for example in some highly original work the Brazilian artist

Photo: Ed Barber.

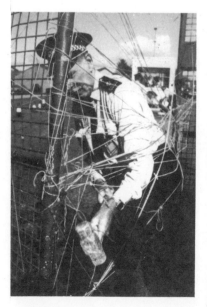

150

5 October 1982. Women obstructing the laying of sewer pipes near the main gates. The woollen webs link them to each other and to the land. Photo: Ed Barber.

Lygia Clark was doing in the 1960s. She had broken with the traditional idea of sculpture as a detached object, in which the body's energy and the artist's expressive power are somehow captured, frozen. She had begun to work directly with her own body and those of others. Her 'sculptures' had become simple, flexible, somewhat organic devices made of rubber bands, polythene, air, stones and so on, which were to be handled, worn, or passed from one person to another. If earlier art had aimed to produce a compressed sign of vitality 'out there', Lygia Clark's signs were inner, representing people's complex sensations of physical existence and identity 'to themselves'. *Mandala* (1969) is a group work. It links a number of people together with a web of elastic bands attached to their wrists or ankles. They may be active or passive, but the movement or stillness of one affects all the others. At Greenham this metaphor of human relations – as a web of interdependent energies – met the more traditional images of patriarchal force!

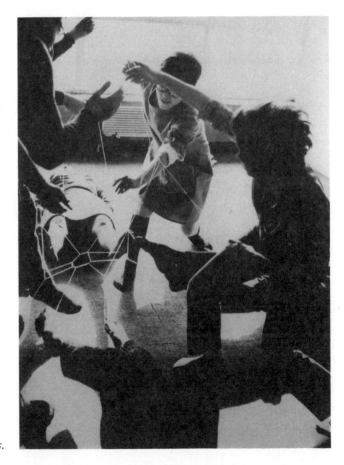

The relationship here is fascinating and revealing with a work of participatory art devised by the Brazilian artist Lygia Clark in the 1960s. In her Mandala, *people link their wrists and ankles together in an elastic web, becoming intensely conscious of one another's movements.*

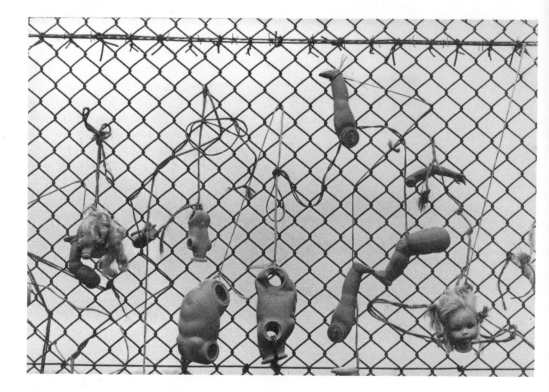

Photo: Mike Goldwater.

One of the most active aesthetic principles at work at Greenham Common has been the translation of context. It could take different forms: putting on public view things from the private world, or working up something exquisite and beautiful from 'rubbish'. It is not the object itself, familiar to everyone, but the transgression of its 'proper' place, which carries the psychic charge. The striking effect of this disturbance of mental habit was first shown by the French artist Marcel Duchamp in 1917 when he exhibited a mass-produced porcelain urinal, as a *Fountain*, in an art show. But now, in a curious and ominous reversal, examples of art or other treasured things were placed in the context of 'manufactured objects' at their most monstrous and alien. Of course, to take on its power, the change of context must assume a compartmentalized, divided world. But at the same time it expresses the desire to break through these divisions and to show that there is nothing sacred or inevitable about them. The movement of objects follows the movement of people.

The practice of professional artists too in our society is very much affected by the problem of context. If a simple object, by being moved from one place to another, can become a potent sign, the signs that artists produce can in turn become inert objects. The context in which artists can gain recognition, support and demand for their work in

capitalist society – the 'system' of established museums, dealers, art magazines and so on – is also the context of art's neutralization. That is why the most conscious and progressive artists and their supporters today are always engaged in a struggle to link the work they do directly with life, to base it in life and in turn to affect life. As I suggested before, the actions at Greenham Common are not necessarily examples of the direct influence of artists. Artistic ideas are in the air, and ripe for use. Nor is it a question of putting art *first*, as a kind of prime mover. As with other examples in this book, the really significant fact is the *relationship* between the people, the event, and the means of expression. At Greenham, the ideas of artists proved their efficacy *at the same time* as people in general proved their desire for self-expression and self-representation, *at the same time* as they felt themselves to be at a key historical moment: understanding the reality of the present and beginning to shape the future. In this combination of forces are the seeds of a new popular culture.

The Bomb and the Stick

At the present time though, what artists do, what the women at Greenham did, is dependent on factors beyond their control. From another point of view, the eloquent symbolic actions at Greenham were the complex, rarified confrontations of a waning liberal society. The form they took presupposes a state refraining from using its full powers of repression – perhaps because the protestors were first seen as harmless, or eccentric, or middle-class. To become a public symbol webs of wool need time and relative peace to be woven. There was no question of webs at the night-time military operation to remove protestors at Molesworth, another cruise missile base, in February 1985, after the events at Greenham had sunk in. The choice of protesting peacefully is proving to be a fragile possession even for relatively privileged groups. That is why ending this book with a description of Greenham Common does not mean to imply that nuclear arms are the greatest threat to the world, or that the artistic manifestations at Greenham are superior or more 'advanced' – in other words letting the West have the last word. When Madhu Kishwar, an Indian woman, came to speak to a meeting of Women for Life on Earth in 1984, she said:

153

A movement for disarmament begins with a move-
ment against the use of guns, the everyday weapons.
Here [in Britain] you may have a fear of a nuclear
holocaust and death and destruction – in India
millions die of water pollution – that is a more deadly
weapon for women in India. I think it is very
important that nuclear piles be made targets for
political action, but we have to begin with confronting
the guns and the *dandas* [sticks]. That is disarmament
for us.[8]

This is precisely the implication of seeing from the
perspective of people, rather than of things.

154

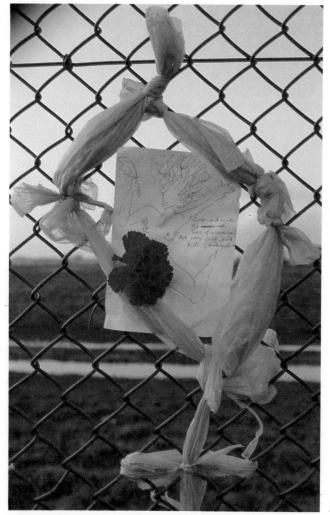

Photo: Maggie Murray.

NOTES TO INTRODUCTION

1. Bertolt Brecht, *Poems 1913-1956* (London: Eyre Methuen, 1976) p452.
2. Joan Halifax, *Shaman, The Wounder Healer* (London: Thames & Hudson, 1982) p11.
3. George Thomson, *Marxism and Poetry* (London: Lawrence & Wishart, 1945, reprinted 1975), p6.
4. Pier Paolo Pasolini, *Lutheran Letters* (London: Carcanet Press, 1983), pp112, 113.
5. Kazuo Kambara, a Hiroshima survivor, in *Unforgettable Fire* (London: Wildwood House, 1981) p109.
6. Johannes Fabian and Ilona Szombati-Fabian, 'Folk Art from an Anthropological Perspective', in *Perspectives on American Folk Art*, ed. M.G. Quimby and Scott T. Swank (New York: W.W. Norton, 1980), p288.
7. Walter Benjamin, *Illuminations* (London: Fontana, 1973) p225.
8. Alfred Einstein, *A Short History of Music* (London: Cassell, 1936) p6.
9. Susan Hiller, 'Sacred Circles: 2000 years of North American Indian Art,' review of exhibition in *Studio International*, London, December 1978, p56.
10. Walter Benjamin, *Illuminations*, p235.
11. These are the last two lines of Brecht's poem *New Ages*, written at the beginning of the 1940s; op cit, p328.
12. Victor Burgin, writing in *Block* no 7 (London: Middlesex Polytechnic, 1982) p16.
13. Alice Cook and Gwyn Kirk, *Greenham Women Everywhere* (London: Pluto Press, 1983) p105.
14. The phrase comes from an essay by A. Sivanandan and was used as the title of his book *A Different Hunger: Writings on Black Resistance* (London: Pluto Press, 1982).

NOTE TO CHAPTER 1

1. This, and the following statements by Chilean *arpilleristas*, have been published anonymously in magazines and small publications both inside and outside Chile.

NOTES TO CHAPTER 2

1. *Socialist Upsurge in China's Countryside*, edited by Mao Zedong (Peking: Foreign Languages Press, 1957) p254.
2. Li Feng-lan, 'How I Began to Paint the Countryside', *China Reconstructs*, Jan 1974, p21.
3. Quoted by Anil de Silva in *Chinese Landscape Painting in the Caves of Tun-Huang* (London: Methuen, 1976) p40.
4. *The Penguin Book of Oral Poetry*, edited by Ruth Finnegan (Harmondsworth, 1978) p50.
5. I am grateful to Chris Crickmay, who visited Huxian in 1982, for this information.
6. Kuan Shan-yue, classical landscape painter, speaking in 1974. Reported in *China Now*, London, Feb 1975, p12.
7. Clement Greenberg's, in 'Avant-Garde and Kitsch', *Art and Culture* (London: Thames and Hudson, 1973) p10.

NOTES TO CHAPTER 3

1. Amilcar Cabral, *Our People are our Mountains*, speech at Central Hall, London, 26 October 1971. Published as a pamphlet by Committee for Freedom in Mozambique, Angola and Guiné, London 1971, p8.
2. My source for the discussion of Shaba painting has been Ilona Szombati-Fabian and Johannes Fabian's article 'Art, History, and Society: Popular Painting in Shaba, Zaire', published in *Studies in the Anthropology of Visual Communication*, 1976 vol 3, no 1, p1.
3. ibid, p10.
4. ibid, p13.
5. ibid, p11.
6. ibid, p12.
7. ibid, p15.
8. Johannes Fabian, 'Popular Culture in Africa: Findings and Conjectures, in *Africa*, London. 48(4), 1978, p327.
9. Amilcar Cabral, *Return to the Source: Selected Speeches* (New York: Monthly Review Press, 1973) p61.
10. H. Ato Delaquis, 'Dilemma of the Contemporary African Artist', in *Transition* 50, Accra, p17.
11. ibid, p16.
12. ibid, p19.
13. Quoted in Ulli Beier, 'Public Opinion on Lovers. Popular Nigerian Literature sold in Onitsha Market', *Black Orpheus* 14, Lagos, p17.
14. An Owerri Ibo villager, quoted in Herbert M. Cole, 'Mbari is Life', *African Arts* vol 2, 3, Spring 1969, p12. For an in-depth study of Mbari, see Herbert M. Cole, *Mbari: Art and Life among the Owerri Igbo* (Bloomington: Indiana University Press, 1982).
15. Chantal Lombard, *Les Jouets des Enfants Baoulé* (Paris: Quartre Vents, 1978) p177.
16. ibid, p184.
17. Reproduced from *Afrikanische Kinder als Konstrukteure*, Ubersee Museum, Bremen, 1979, p30.

NOTES TO CHAPTER 4

1. Quoted in the *Guardian Newsweekly*, New York, 29 April 1981, p2.
2. Toshiko Akamatsu and Iri Maruki, *The Hiroshima Panels*, in the catalogue for the British tour sponsored by the Anti-Hydrogen Bomb League and Artists For Peace, 1958.
3. ibid.
4. ibid.
5. More information about the book can be obtained by writing to the Hiroshima-Nagasaki Publishing Committee, Heiwa-kaikau, Shiba 1-4-9, Minato-ku, Tokyo 105, Japan.
6. *Hiroshima-Nagasaki – A Pictorial Record of the Atomic Destruction* (Tokyo, 1978) p340.
7. *Unforgettable Fire*, edited by the Japanese Broadcasting Corporation (London: Wildwood House, 1981) p105.
8. ibid, p109.

NOTES TO CHAPTER 5

1. Jane Hickman, quoted in Alice Cook and Gwyn Kirk, *Greenham Women Everywhere* (London: Pluto Press, 1983) p118.
2. Theresa, quoted in *Greenham Common: Women at the Wire*, edited by Barbara Harford and Sarah Hopkins (London: The Womens Press, 1984) p159.
3. *Greenham Women Everywhere*, p121.
4. ibid, p118.
5. Quoted by Judy Chicago in *Through the Flower* (London: The Womens Press, 1982) p145.
6. David Medalla, writing in *Paletten* 1, Stockholm, 1968.
7. Virginia Woolf, *Women and Fiction*.
8. Interview in *Outwrite* 22, Feb 1984. Quoted in 'Challenging Imperial Feminism' by Valerie Amos and Pratibha Parmar, *Feminist Review* 17, London, July 1984, p3.

The following books are also available in GMP's Heretic series:

Rudolf Bahro

£5.95

BUILDING THE GREEN MOVEMENT

A provocative collection of essays by a leading figure in the West German green movement, with an international reputation.

and

£3.50

SOCIALISM AND SURVIVAL

This earlier collection charts Bahro's progress from red to green, in the first years after his arrival in the West.

Kath Clements

£2.95

WHY VEGAN

Examines the moral, political and economic arguments for ending our exploitation of animals.

Kit Mouat

£2.50

FIGHTING FOR OUR LIVES

A book on the pioneering work of Cancer Contact, a mutual aid network of people unwilling to see themselves as passive victims.

Peter Tatchell

£3.50

AIDS: A GUIDE TO SURVIVAL

A welcome message of hope for the many people exposed to the AIDS virus, showing the many ways in which they can increase their chances of survival.

and

£3.95

DEMOCRATIC DEFENCE

"a welcome contribution to rethinking the nature and purpose of defence" (Bruce Kent).